THE
PHOTOGRAPHER'S
GUIDE TO
NEGOTIATING

Richard Weisgrau

ALLWORTH PRESS
NEW YORK

08 07 06 05 04 5 4 3 2 1

Published by Allworth Press
An imprint of Allworth Communications, Inc.
10 East 23rd Street, New York, NY 10010

Cover design by Derek Bacchus

Interior design by Mary Belibasakis

Page composition/typography by Integra Software Services, Pvt., Ltd., Pondicherry, India

Cover Photo Credit: Paul Godwin

ISBN: 1-58115-414-3

Library of Congress Cataloging-in-Publication Data

Weisgrau, Richard.
 The photographer's guide to negotiating/Richard Weisgrau.
 p. cm.
 Includes index.
 ISBN: 1-58115-414-3 (pbk.)
1. Commercial photography. 2. Photography—Business methods. 3. Negotiation in business. I. Title.

 TR690.W44 2005
 770'.68'4—dc22

 2005013090

Printed in Canada

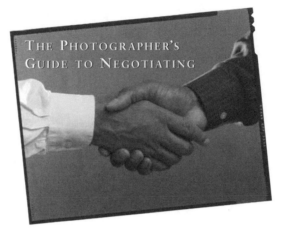

THE PHOTOGRAPHER'S
GUIDE TO NEGOTIATING

Table of Contents

Introduction

Is negotiation an art? If you accept the definition of "art" to be a skill acquired by experience, then negotiation is an art. But, if you think of art as the use of creative imagination, that is, some form of expressed innate originality, then negotiation is not an art. Too many photographers seem to believe that negotiation skills are innate. They see the successful negotiator as having been born with, rather than having acquired, negotiation skills. They imagine themselves not having been so blessed. It's time to dispel the myth that only some people are lucky enough to have been born with the ability to negotiate. It is time that we all realized that each and every one of us was born with that ability.

Any parent of a young child of speaking age has had the experience of negotiating. The parent may not recognize it as a negotiation because the exchange is often so natural and

seemingly insignificant. The perfect example is bedtime. By the end of a day, children often become more restless or noisy as they grow more tired. It is a signal to the parent that it is bedtime. The simple order "time to go to bed" is often met with resistance. Repeating the unwanted order seems to spark some reflex to negotiate. The child might reply with, "Please let me stay up longer. I'll be good." The parent might respond with "OK, ten more minutes, but you have to sit quietly." "OK, I will," replies the child. A compromise has been reached, a deal made, and a negotiation finished.

You can probably cite dozens of examples of simple negotiations that have gone on in your life, such as working out how you will spend a day with spouse or friend, or agreeing with a co-worker on how to divvy up a workload. All those experiences fit within a broad definition of the word "negotiate": to confer in order to reach an agreement. Conferring is nothing more or less than communication, something you do every day. All of us were born with the ability to communicate. Communication is not a process dependent upon originality or creativity. We are all born communicators. Some of us take the time and expend the effort to become better at it than others— that is, we hone our skills so we might have an edge when needed. The *ability* to negotiate is innate. The *skill* of negotiation is developed. Like everyone else, you can develop those skills, if you choose to.

One of the reasons that some people tend to think of negotiation skills as a gift given to only some of us is because as youths we were often inadvertently conditioned to avoid negotiating. How often did we hear our meager attempts to negotiate that extra ten minutes of wake time simply rejected with a firmer order to go to bed, or maybe even a threat if we did

not follow the order? How many times was an attempt to work out a problem with a teacher simply rejected with an authoritarian rebuff? In our youth, most of us were faced with countless situations in which acceptance was the only option, because the alternative was either punishment or some other kind of negative result that we did not want to experience. Think about how many times in your life your attempts to negotiate were simply rebuffed, when all you really wanted was to confer with a person in authority about something that was important to you. What was the long-term effect of those rejections? Most likely, they conditioned you to believe that negotiation isn't usually an option when an authority figure is on the other side of the table. Couple that preconditioning with a general tendency to think of anyone who you are hoping to persuade as having authority, and you have all the conditions necessary to lead you into thinking that you can't negotiate. After all, your earliest experiences proved this to be true, and perhaps your current experiences often seem like a repeat of an earlier situation. It is a recipe for believing that you have no alternative but to take what is offered. The recipe, if followed, is sure to serve up unpalatable meals that provide little satisfaction and insufficient nourishment. In other words, not knowing how to, or failing to, negotiate almost guarantees that your interests will suffer.

Decades ago, when I first joined the ranks of professional photographers, I knew nothing about negotiating. I was a victim of my own ignorance. I felt that I could not negotiate with clients because it would be futile. I was paid what the client wanted to pay me. I didn't strive for greater fees because I was afraid to lose the job being offered to me. Over a period of a few years, I saw that my business was not going anywhere. My earnings

were static. I was facing the prospect of many unpalatable meals that I spoke of above. I had the good fortune to be one of those types who did something when corrective action was needed. I found a mentor or two—successful photographers—who quickly convinced me that I was doomed to fail if I didn't learn to get what I was worth from my clients, instead of what they were offering to pay me.

In those days there were no books like this one. Books about business and negotiating offered very general information. The reader had to apply the principles to his or her own circumstances, and to learn by doing instead of by reading. That is what I did. I read a dozen books on negotiating, and I applied what I read to my business. Gradually, over a few years, I learned how to make negotiating a routine in my business life. That knowledge proved to be invaluable throughout the years I operated my photography business and served as executive director of the American Society of Media Photographers (ASMP), and it is equally valuable now, as I work at being a photographer, writer, and consultant.

Today, there are many books that deal with business from the photographer's perspective. But there are none that I know of that have more than a chapter on negotiating. I wrote similar chapters as a contributor to the *ASMP Professional Business Practices in Photography*, and as the author of a book called *The Real Business of Photography*. (Both of these books are published by Allworth Press, the publisher of this book.) While such chapters are valuable, and much better than having nothing specifically directed at the photographer, the fact is that developing a full set of negotiating skills requires more knowledge than those chapters can convey. That is why I have written this book. I want to help photographers learn that negotiating is not only possible in the photography business, but that it

is imperative to the well-being of their businesses. Moreover, I want to help photographers learn how to negotiate in the variety of situations that they encounter in business—from buying to selling to settling disputes. I hope that you will read and profit from this book.

Chapter One

The Nature of

Negotiation

Developing your skill as a negotiator, like all skills development, requires that you understand the process. Unlike the photographic-exposure process, which has been crammed onto a memory chip in programmed cameras, the negotiating process is not scientific, so it can't be reduced to formulas. A decade ago, a software company released a series of programs that were intended to guide a person through a negotiation. Those disks can't be bought now. That software company went out of business because it was (and still is) impossible to create an artificial intelligence that is sophisticated enough to formulate strategies, adjust them as things change, and understand that things are changing as you speak. Negotiations happen in real-time and space, not cyber time and space. So far, the only computer that seems able to handle the negotiating process is the human brain.

Step one in preparing your most personal of computers, your brain, for the negotiating process is understanding the purpose for, and process of, negotiating.

DEFINING NEGOTIATION

In his book *Power Negotiating* (Addison-Wesley, 1980), John Ilich, a professional negotiator, said: "In its purest form it [a negotiation] is mind pitted against mind." It is hard to argue against Ilich's statement. While negotiating is a process of conferring with another to settle a matter, that process is very dependent upon the mental processes of the parties trying to settle.

The negotiating process is one of communication: two or more people seeking to resolve a matter with an outcome that is acceptable to all. An agreement is reached through an understanding of the positions of all the parties and by balancing points of view. "Understanding" is a key word, defined as "to grasp the meaning or reasonableness of." It is the core of all mental processes. It is the core of negotiation. Whether the negotiation involves a labor dispute, the ending of a conflict, an insurance settlement, or a business deal, the process always involves working with another party, trying to grasp the reasonableness of each others' positions, and modifying those positions to make them reasonable in each others' minds. With those thoughts in mind, let's write our own definition of negotiation. Negotiation is a process of reaching a mutual understanding achieved through a meeting of the minds based upon the acceptance of the reasonableness of each other's position.

FAIR VALUE

No matter what walk of life you follow, one thing is certain. People you associate with will disagree. That does not imply that all disagreements are adversarial or hostile. Differences of opinion do not usually cause hostility unless they are rooted in some ideology that prevents the parties from accommodating each other's point of view. Fortunately, business is most often a practical matter, and very few business impasses exist that cannot be resolved through negotiation.

It is important to understand the basis of most practical disputes. Unlike ideological arguments, which revolve around abstract values, practical disputes are based on concrete values. Disagreements in business are almost always centered on concrete values, such as money, timing, benefits, duration, etc. That is why most business disagreements can be resolved. The ability to assign an economic value to disputed elements of a business matter means that a corresponding value can usually be found to offset the disputed value. Wages are often described in dollars per hour. Wages are agreed by a process of negotiating the value of an hour or the amount of time a dollar will buy. Being able to assign a value to an item makes it much easier to negotiate over that item.

Understanding the relationship of value to negotiation, we see that business negotiations are usually aimed at equitably trading value for value. Done successfully, the process ends in each party receiving what they agree is fair value for fair value. This is sometimes called "Win–Win" negotiating. I don't like to use the word "win" in relationship to negotiating. "Win–Win" implies that both parties come out as winners. In my view, there are no winners or losers in a fair trade. So I like to think of a successful negotiation

as fair trading. In business, there is nothing more honorable than making a fair deal, which means not taking advantage or being taken advantage of.

Wants and Needs

In order to make a fair trade, the negotiating parties must achieve a balance between their positions. To do that, we have to understand the parameters within which any negotiating position rests. Business interests are best described as a continuum, with wants at one end and needs at the other. Wants represent a higher value and needs represent a lower value.

A colleague of mine once described his "wants" as his "whoopee" price, meaning if he received it, he screamed "whoopee" under his breath. He described his "needs" as his "whew" price, meaning he went "whew" with relief if he could close a hard-to-get deal at that level. By that analogy, we can see that wants are a desire and needs are a necessity.

Another way to visualize the difference between wants and needs is by considering your personal relationship to an automobile. You might *want* a Mercedes Benz, but you *need* a car that runs reliably. The distance between the ends of that continuum are far and the options are wide. There are literally hundreds of options that meet almost every purchaser's ability to pay. What kind of automobile you end up with will depend on your financial worth and, yes, your ability to negotiate a good deal for yourself.

Negotiating is a process of moving back and forth between wants and needs until each negotiator agrees that an acceptable balance between all the parties' wants and needs has been achieved. Compromise is the linchpin of negotiating.

Compromise is not a sign of weakness in a negotiation. It is a sign of intelligent bargaining.

TYPES OF NEGOTIATION

In business, we generally experience three types of negotiation: terms-and-conditions bargaining, price bargaining, and dispute resolution. I listed the three types of negotiation in the order they usually come up in a business scenario. The terms and conditions of any deal are likely to affect its price. Therefore, we ought to resolve those details *before* we try to resolve the price. If we reach an agreement of terms and conditions *and* price, we are unlikely to have to resolve a dispute resulting from the original agreement. (Dispute resolution, unlike the bargaining over terms, conditions, and prices, is often adversarial in nature. In the worst-case scenario, disputes must be resolved in courts, if they cannot be resolved by negotiation.)

The three types of negotiations are similar in most regards. Wants and needs cap each end of the value equation. Bargaining over terms, conditions, and prices is really part of the selling process. In the salesman's language, it is called "closing" the deal. It is the process of listening to your client's objections and providing good reasons for your position or alternatives to them. Because you are trying to sell something, it is usually a friendly exchange. "Friendly" does not mean it is not businesslike. In business, amiability produces better results than indifference or hostility.

Dispute resolution is rarely friendly. It is adversarial by its nature, and that means it can become hostile. While hostility serves no one's purposes in settling a dispute, when a party feels wronged it is often difficult for him to control or mask his hostility.

One reason for this is because a dispute is usually seen as a win-or-lose situation. No one wants to be the loser. Where there are winners and losers, there is a contest. A contest usually gets adrenaline flowing. The heart rate goes up, and the emotions peak with the increasing beat. It is instinctive behavior, dating back to our prehistoric ancestors. Losing for them was likely to mean that they were going to be a beast's dinner, or maimed at best. Human defensive reactions haven't changed over the millennia. The reasons we get defensive have multiplied, but in the end none of us want to be the symbolic "dinner" of another, so we dig in for the fight, and we usually get one. The important thing to remember is that by conducting complete and proper negotiations in the early stages of making business arrangements, we can usually avoid subsequent disputes.

Conditions for Negotiating

Negotiating is dependent upon two conditions, both of which must be met before the process can begin. First, there has to be some level of disagreement between the parties' positions. If there isn't, then there is nothing to negotiate. I have actually met some people who like the challenge of negotiating so much that they will work hard to find something to disagree about, just so they can negotiate. Personally, I think one should try to control neurotic behavior in business, so I'd suggest that you resist the temptation to bargain unless you have a better reason than just because you feel like it.

Once there is some level of disagreement, the second condition is that the parties on both sides of the disagreement must be willing to negotiate. Sometimes, one party may not be willing to negotiate, preferring simply to move on if the other party

does not accept his or her position. In that case, a negotiation is impossible, because you can't have a "meeting if the minds" unless there are at least two minds engaged in the process. Sometimes, a person will appear to be unwilling to negotiate. That is not always a sign that a negotiation is impossible. It is often a feint aimed at getting you to accept their terms without discussion. It works, if you let it. There are ways to deal with such a feint, and we will explore them in the chapter on negotiating tactics. However, when you encounter a person who is truly unwilling to negotiate, you have little to gain in dealing with him. If the substance of his non-negotiable offer does not meet your needs, you simply walk away from the deal, not the person. There might be a next time, and it might be a negotiable offer next time. Don't alienate a person who refuses to negotiate. Business dealings are always in flux. What characterizes one situation with one individual does not necessarily characterize all other situations with that same individual. Always be open to an offer.

BARGAINING ISSUES

The issues involved in a negotiation are usually divided into two types: principle and position. Principle bargaining involves abstract issues, such as your business policies. Position bargaining involves concrete issues, such as money and time. While principle and position are connected, they are dealt with separately in a negotiation.

By "principle," I mean any policy that usually guides your business dealings. Compromising over your policies is acceptable, as long as you do not compromise your ethical values or legal obligations. Your business policies might include things like

requiring an advance on expenses, or requiring that clients pay modeling agencies directly, so you do not have to finance their work to a greater extent than necessary. Compromising on such a principle amounts to breaking your own rule. Is that OK? Some rules were meant to be broken sometimes. Whether you break a rule will usually depend upon how important the deal is to you and which rule you are asked to break.

By "position," I am referring to value level. You have one idea of value in dollars and the client has a different view. Your positions are different. The difference in positions has to be worked out, and there are ways to do that. Unlike principle bargaining, in which you have to decide whether a job is worth breaking your rule(s), in positioning bargaining you are usually deciding whether you can accept a price, or terms and conditions, while still meeting your needs.

STAGES OF A NEGOTIATION

There are four stages in the negotiating process: investigation, evaluation, alternative development, and reaching agreement. For the most part, these stages occur in order, with two of them, investigation and evaluation, usually happening concurrently. Through investigation, you will already have gained some information about the client, the assignment, etc. As you speak with your negotiating counterpart, you will be receiving new information that complements the information you already have. You will have to incorporate that new information into your prior evaluation, if it is likely to cause a shift in your position. New information often requires that you re-evaluate.

All too often, photographers impede their chance of a successful negotiation by not knowing that the four negotiating stages

require thoughtful planning, with thorough attention to details and follow-through. Understanding the importance of each stage is critical to being a good negotiator, so we will consider each separately below.

The investigative stage of a negotiation is nothing more than information gathering. The investigation is done by trying to obtain the answers to a series of questions related to the object of the negotiation. The circumstantial questions—who, where, what, why, when, and how—define the framework of the investigative stage. (In chapter 3, Planning for a Negotiation, you will find a series of checklists and notes that will help you in gathering the facts that you will need to negotiate in different situations.) Obviously, it is not always possible to know every answer with certainty. Some answers are going to be your best guess. But certainty is luxury in a negotiation, so you must become used to the fact that you never have all the facts. Business is a calculated risk. Fact-finding is a way to reduce risk to a prudent level, not eliminate it. Fact-finding means evaluating (stage two of the process) the information that you have gathered to determine which useful facts you have acquired.

The investigative stage, the first stage we should undertake, in a negotiation is the most often neglected. It takes some careful and considerate work. But, properly done, it will increase your power in a negotiation. Information leads to knowledge, and knowledge leads to power. Negotiating power is something that you should never neglect. (That will become clearer in chapter 3.)

Evaluating all the information you have acquired for useful facts is the second stage of the negotiating process. You must determine how the facts might influence your negotiation. Facts are evidence of something. The question is what is the evidence telling you. Logically, if you don't intend to evaluate the facts

you have acquired, you ought not waste time gathering those facts. It will save you some work, but it will also probably assure that you will not develop a negotiating strategy. Strategy is the product of your evaluation and its influence on the tactics you will decide to use while negotiating. As you assess information and determine useful facts, you can anticipate probable disagreements that will require negotiation. That allows you to formulate approaches to resolving those problems if and when they occur.

The third stage involves developing alternatives to what your evaluation tells you might be stumbling blocks. If you anticipate that a specific problem might arise during the course of negotiating, then you should take some time to consider how you might deal with the problem—that is, what alternatives can you suggest that might solve the problem within the parameters of the wants and needs of the parties.

The fourth and final stage of a negotiation is the agreement process. This is the period of time during which you will discuss the discussion with the other involved party. This is the time during which you are expected to communicate clearly to explain your position, understand your opponent's position, and work toward balancing those positions.

PROCESS INTEGRITY

Negotiation is a process of reaching an understanding through a meeting of the minds. The process is one of fair trading to find the points between each party's wants and needs that allow each side to accept a deal without feeling taken advantage of. The process is the same, whether you are closing a business deal or settling a business dispute. Initiation of a negotiation rests

on the willingness of all parties to negotiate with an understanding of each other's principles and position, which should be dealt with in order of priority. Diligence in working through investigation and evaluation of the facts will enhance the probability of successfully reaching an agreement. Negotiating is a process, and, like all processes, it must be done in a systematic and thorough manner.

Chapter Two

Traits of a Good

Negotiator

The financial health of your business is stated in a balance sheet that compares the assets of your business to its liabilities. As negotiators, we have assets and liabilities of a different sort. We might better call them strengths and weaknesses. Just as we have to be aware of our assets and liabilities to stay in business, we have to be in touch with our strengths and weaknesses as negotiators if we are to be successful at the negotiating process. We also have to be aware of the strengths and weaknesses of our counterparts.

Your negotiator's balance sheet is a measure of how you stack up in terms of the attributes that it takes to be a successful negotiator. As you read about these attributes, remember that attributes, like assets, are acquired over time. You may not have them now, but you can have them tomorrow if you dedicate yourself to acquiring them. The first step to ensuring that you

possess or will posses them is to know them. Let's look at each of them individually.

SELF-CONFIDENT

You wouldn't hire a lawyer who didn't believe he could properly represent you. You wouldn't hire a doctor who didn't believe she could give you proper medical care. Your clients wouldn't hire a photographer they didn't believe could successfully complete an assignment. We want all the people who represent or serve us to be self-confident. Self-confidence is more than just a feeling of competence. It is knowledge of one's ability and a commitment to succeed. It is demonstrated in the way you walk, stand, sit, and talk. It is revealed in the way you look a person in the eyes when addressing him. It is a belief in yourself.

It is important that you believe in yourself as a negotiator if you are to be successful at the process. You have to build that belief by a commitment to studying negotiation, learning its techniques, practicing what you learn, and understanding that self-confidence flows from training. Take a moment to think about the nature of training. The military is a perfect example of what training can mean to the individual. The soldier trains endlessly. He learns to respond instinctively to any stimuli instantly. With several years of training under his belt, his confidence in himself has been earned by hard work. You have trained to be a photographer. If you have been trained well, you have confidence in your photographic ability. The same principle applies to negotiating: You must train to be competent. As your training advances, your confidence in yourself will increase. In time, you will know that you can handle anything

that can be dropped in your lap or thrown at you, because you will be a trained negotiator.

COMMUNICATOR

Negotiation is communication aimed at settling a matter. If you can't communicate, you can't negotiate. But don't think of communication as being the achievement only of a great orator or writer. The level of communication skill needed for negotiating is only enough to make your position understood by another person. A sophisticated vocabulary is an asset to an essayist or an academic, but it isn't going to make a difference in a business negotiation. Most business dealings are best done in simple, easy-to-understand language. Which of the following two sentences is easier to understand? "I can't allow myself to experience an excess of expenses over revenues as a result of accepting your offer"; or, "I can't accept this job on your terms because I will lose money." The point is this: It is better to convey a direct message in simple terms when negotiating.

When you were a child you could only express your needs in the simplest of terms. Those caring for you easily understood your words. I know that most photographers do not spend their lifetime improving their verbal skills, as they are more intent on improving their visual skills. Well, the good news that it doesn't matter. If you can speak the language at its most basic level, you have the verbal skills needed to negotiate. I am not saying that you should not try to improve your verbal skills if they are lacking. If an asset is weak, you want to strengthen it. I am saying that you need only basic communication skills to be a good negotiator.

FACT FINDER

Knowledge is a key element of success. Information is the core of all knowledge. Acquiring the information you need to bring about a successful negotiation is a critical component of your overall effort. Negotiators usually refer to fact-finding as "doing homework." As a learning process, it prepares you to pass the tests that you will face.

Fact-finding has two steps. First you investigate to get every piece of information that is relevant to your negotiation. Then you decide which facts actually shed some light on a good negotiating strategy. The process amounts to finding all the facts that you can, then finding the useful facts among the total collection.

I can't emphasize the importance of fact-finding enough. Knowledge is power, and power plays a role in negotiation. One way to cultivate power is to be knowledgeable about your client, the offer being negotiated, and your competition. Fact-finding is the way to acquire that knowledge.

ORGANIZED THINKER

An organized thinker is a person who forms his thoughts in a uniform and structured manner. He has a consistent and logical approach to determining what he thinks. As a photographer, you have a consistent, repetitive, and logical way that you approach the technical aspects of your photography. While you might have a different way of using your creative function, your technical side consistently follows a logical path. What you photograph changes, but the process does not. So it is with negotiating.

As a negotiator, you must learn to follow certain thought processes. The investigation and evaluation stages of negotiation

are patterned—that is, they have an organized motif. If you want to succeed as a negotiator, you have to learn that the process of negotiating will be consistent from one negotiation to the next. The only changes will be in the issues and the people presenting those issues. You will know that most business issues involve the same factors—what you get for what you give.

VISUALIZER

A very revealing study of the benefits of visualization was conducted by a group of researchers in the 1980s. They wanted to determine the difference in benefit between actual practice and visualization of the practice. They decided that the study would only have significance by comparing a sample of participants engaged in a single pursuit for limited period of time. Two basketball teams of equal ranking in skill were selected to be the test groups. The measure of success would be how many baskets could be successfully made from the free-throw line in a set period of time by each team. The variable would be the means of preparing for the contest. One team was to practice free throws on the court for half an hour before the actual shoot-out began. The other team was to visualize, off the court, the act of shooting free throws, as if they were actually shooting the ball. At the end of the practice and visualization period, the teams engaged in the competition. Each team shot at an opposite end of the court, making as many free throws as possible in the same period of time. When the time was up, the team that had used visualization won the shoot-out by more than 10 percent. No one knows exactly why that happened, but this and similar experiments have proven that visualizing contributes to success and can be just as effective, if not more so, than actual practice.

Photographers have strong visualization skills, which are the basis of their creative talent. These skills are usually employed in envisioning a subject in a certain manner. Using this skill to visualize yourself as a negotiator adds an asset to your balance sheet. You have to see yourself in the role of a successful negotiator. You have to visualize the process that you will be going through to beef up for the game. There is little opportunity to practice for a specific negotiation, but there is always opportunity to visualize negotiating with another person, thereby perfecting your skills.

Fair-Minded

A good negotiator expects and demands to be treated with fairness and understands that treating his negotiating counterpart fairly is the only way he can expect the same kind of treatment. Books have been written about fairness in negotiation. The problem is that these books don't define the word "fair" or "fairness" beyond implying that an agreement of equal value to both sides is fair. Well, I can accept that as a guideline for deciding whether a negotiation was successful, but I am speaking of the asset of being fair minded, not of fairness of an outcome.

"Fair minded" means being marked by honesty and impartiality. It has nothing to do with an outcome. It is all about input, not outcome. Good negotiators are honest in their dealings and impartial in their treatment of counterparts. They apply the same principles and policies in all their dealings. It is a fairness of treatment, not of outcomes, that distinguishes the successful negotiator. By dealing with others honestly and impartially, and insisting on receiving the same kind of treatment that you give, you will do more to ensure fair outcomes than by any other means.

How do honesty and impartiality merge to make fair-minded? It's simple. You just have to be honest with, and apply the same rules to, all. You don't take advantage of the weak, and you don't allow the strong to take advantage of you. You are honest with all, and you expect all to be honest with you in return. You are consistent in the treatment you give and the treatment you demand. Being fair-minded distinguishes you as being a plain dealer. Plain dealing and common sense are traits of a good negotiator.

Option-Oriented

As mentioned earlier, negotiating success is often dependent upon finding acceptable alternatives to existing but unacceptable positions. Finding alternatives is nothing more than developing options. Most often there is an alternative way of doing something. The skilled negotiator thinks about acceptable alternatives as a part of preparing for a negotiation. Once you have developed your position, assume that your counterpart will reject it or some part of it. Then you develop alternatives. It is even possible that you will present all the alternatives initially, if all are equally acceptable to you.

Developing options requires that you either anticipate reactions to your position or anticipate your counterpart's positions. For example, if you anticipate that your client will ask you for the copyright to the images you make, you might develop an alternative of providing exclusive and unlimited usage rights for a limited period of time and for a lower fee than for a copyright transfer. That option to the demand provides the user with the rights of a copyright owner for

a specific period of time, and it saves the client money. You accept less money because the client agrees to give up perpetual ownership of the rights. As you can see, the option has a benefit for each party. You will keep the long-term rights, and the client will save money while getting a liberal but not total grant of rights.

Alternatives have to deliver benefit for both sides to be effective. If your initial position is rejected, it is likely because there was not enough benefit for your counterpart. If the alternative you propose is also perceived to be lacking benefit, it will be rejected, too. Alternatives are not options unless they offer some benefit missing in your original position.

DECISION MAKER

The negotiation process involves making decisions. Each bargaining issue is evaluated, discussed, and decided. When all the issues are decided, an agreement has been reached. You cannot avoid making decisions in a negotiation. "Indecisive negotiator" is as much an oxymoron as the words "square circle." The competent negotiator is ready to make decisions and has a process for doing so.

Making decisions about issues in a negotiation is not rocket science. In fact, it is very simple, because by its nature negotiating is a process of balancing wants and needs. Therefore, as long as your needs are met, it is all right to accept the outcome. That does not mean that you should strive only to meet your needs. It is more satisfying to do better than the minimum acceptable to you. It does mean that decisions are based upon how close they take you to your bottom line. In the end, never

settle for less than your needs. That is the basis for every decision you make in a negotiation.

COMMITMENT KEEPER

Once you have made a decision, you have to be able to live with it. Sometimes we make bad decisions that are irreversible. If you make a commitment in a negotiation, you have to uphold it, even if you know it was a bad decision on your part. You can always go back and ask to renegotiate a deal or issue, but you have to uphold your commitment if renegotiation is not possible or is unsuccessful. If you break a commitment made in a negotiation, you can be sure that you will not get the opportunity to negotiate with that particular party again. Sometimes it is painful to fulfill a commitment, but it is more painful and can be fatal to lose business because you failed to fulfill a commitment.

TRANQUILITY SEEKER

Tranquility is a state free of mental agitation or other disturbances. It is easy to become disturbed with a person who does not agree with you, especially when you cannot understand *why* they don't agree. At the same time, mental agitation is the negotiator's worst enemy. An agitated mind is not a mind that thinks clearly. A negotiation is a battle of wits, or reasoning power. It follows that a mind thinking clearly is "wit-full," while the agitated mind is either witless or wishful. Reasoning power is the key to understanding. Mutual understanding is the key to successful negotiating. Tranquility is a key component of understanding.

EMPATHETIC

Unlike sympathy, i.e., feeling sorry for another, empathy is vicariously feeling what another feels and understanding the depth of those feelings. It usually requires that you have been in the same position as the other party, or that you have seen enough in life to understand the depth of the other's feeling. Notice that the word "understanding" appears as part of this attribute. Empathy can help us understand our counterpart's position. That, in turn, can help us craft alternatives that might be acceptable to that party, or even to make concessions with the intention of cementing a relationship. A little bit of understanding in the first round of a negotiation can go a long way in making the next rounds easier.

Sympathy is something you might feel, but one rule of negotiating is not to adopt your counterpart's problems. You will never cure problems that warrant sympathy. You have your own problems. You can understand the other party and adjust your position accordingly, but do not cut the other side slack because you feel sorry for him, or you will be doing it for him forever. Business is business. Understand business problems, but don't cave in because you feel sorry for the person or company with the problems.

FLEXIBLE

There is a reason that trees bend in the wind. The alternative is to be ripped out by their roots. Flexibility in a negotiation is directly related to your ability to accept compromises in the form of alternative courses of action. On the other hand, being rigid is the inability to do so. Reaching a mutual understanding requires that you be flexible. The world does not revolve around your wants or needs.

It revolves around a spirit of compromise. If you are not flexible, you cannot successfully compromise. Unless you have some magic that the rest of the businesspersons in this world do not have, you cannot survive in business without making compromises. There is a great divide between compromising and selling out. Being rigid drives you off one cliff. Being too flexible drives you off another. Your flexibility always rests in the space between your wants and needs. Flexibility is bending your position but not below your bottom line.

INQUISITIVE

People learn by exploration, study, and asking questions. Much of today's knowledge has grown from probing by people with inquisitive minds, people who just wanted or needed to know more about what was in front of them, on their mind, or in their imagination. Asking questions is an important part of the investigative stage of a negotiation. There is no substitute for gathering information and for fact-finding in preparing for a negotiation. In a complex world of busy people, the best way you can find out what you want to know is to ask someone questions. (In chapter 3, Preparing for a Negotiation, you will be introduced to a series of questions that you might ask as part of your investigative effort in preparation for a negotiation.)

LISTENER

For the great majority of people, hearing is an involuntary act. You can't turn your hearing off and on—like you can your eyesight by closing your eyes. Since we hear all that is audible all day long, our brains have learned to ignore certain sounds, so we can

remain undistracted, at rest, or actively listening to what we choose. Actively listening is an important part of negotiating.

The inquisitive negotiator asks questions and then actively listens to the answers. Most of what we want or need to know in a negotiation is available to us from our counterpart, but that information is useless if you do not listen and absorb it. All of us have had the experience in which we have heard a person say something but not grasped or retained it in our mind. We heard the words, but we did not listen. You should guard against this happening during any part of a negotiation.

Listening requires active involvement of the brain, not just the ears. It is quite easy to be distracted by one's own mental processes during the course of a discussion. Maybe you hear something that concerns you because you didn't expect it, so your mind drifts to that item instead of what you are hearing next. It is not uncommon, but you have to fight the tendency to focus on such a distraction. That does not mean that you ignore it. Instead, make a written note of it and keep listening to what you are hearing. Your note will remind you, at the proper time, to think about whatever distracted you.

PATIENCE

Patience is a trait that many photographers should work on. The high-speed demands of the profession and the desire to see images sooner rather than later contribute to a tendency of photographers to want to get things done fast. Impatience can prevent you from actively listening. It can also undermine your whole effort, because rushing a process usually impairs its quality. You have to learn to wait for the other side to come around. You have to wait for them to express themselves. Good communication cannot be rushed.

REFLECTIVE

Good negotiators are both thoughtful and deliberate, not only about their anticipated actions but also about past actions. Being reflective will help you in two important ways. First, in a continuing relationship, a thoughtful look back at past negotiations and other ramifications of the relationship can provide you with the insights into how to handle the current situation. Second, being reflective will help you develop a better understanding of yourself, including what you have done right and wrong in past or current negotiations. Looking back at your and others' actions, whether they took place months or minutes ago, is a good habit to develop. Scientists learn by studying past failures as well as their past successes. Reflecting on what went wrong or right helps you repeat the right and avoid the wrong.

ASSESSING AND ACQUIRING TRAITS

This chapter has focused on the characteristic traits of a good negotiator. You need to reflect on your own capability in this regard. If you find yourself lacking in some areas, it means that you have to stay conscious of the shortfall and work on improving the deficiency. Many of these traits are interconnected, such as Inquisitive, Listener, and Fact-Finder, or Decision Maker and Commitment Keeper. Allowing a deficiency in one trait can damage another.

The traits of a good negotiator are easily acquired or improved. It all starts with recognizing what they are, and this chapter has told you that. Then some self-assessment is in order. You will find yourself lacking in some areas and well stocked in others. You must focus on those you lack. These traits are the negotiator's assets, and, as your business cannot survive without monetary assets, your dealings will be unsuccessful without negotiating assets.

Chapter Three

Planning for

a Negotiation

Whenever you are reaching for a goal, there is no substitute for planning. Planning is an essential aspect of negotiating. Negotiators plan to avoid being caught off guard. Surprises often knock people off track. Sometimes they even cause panic. Negotiating panic is a fear reaction, and it is usually caused by a sudden threat, an unanticipated attempt to impose a condition, or the uncovering of important facts that have not been previously considered. Panic is a loss of mental control, which means you do not have your wits about you—and you know how important it is have your wits about you when you negotiate. Planning is the way to avoid surprises. If you have done your investigation and fact-finding well, you are unlikely to be surprised.

Some negotiations require intense planning that may take days. Other negotiation planning may only take minutes, because

you will have been down that path so often that your plan doesn't change. That will be true when you have repeated negotiations with the same party. Many of the techniques in this chapter will not have to be repeated when dealing with a familiar counterpart. Regardless of the necessary level of your planning, all planning starts with formulating questions that you ought to have the answers to, or at least consider, in order to negotiate successfully.

In your early school years, you were most likely taught the circumstantial questions: who, what, when, where, why, and how. Those questions might have been called the "investigative" questions, because all investigations aim to answer them. Now we can look at how to apply them in planning for a negotiation.

HOMEWORK

Planning for a negotiation is like doing homework for a test. It is a process of learning all that can be learned and deciding what is most likely to be needed for the test. The combined investigation, evaluation, and alternative-development stages of negotiation are the planning process intended to get you ready for the fourth stage—reaching agreement. In school, poorly done homework can often make the difference between a passing and a failing grade. When it comes to negotiation, poor preparation can lead to analogous result. Many photographers shy away from planning for a negotiation. They don't avoid it because they are incapable of doing it. Instead, they avoid it because they don't understand the process, or importance, of such planning. Like all planning, planning for a negotiation

is best guided by consideration of the many things you have to think about before any negotiating begins.

Six Basic Elements

The most complex problems are solved by breaking them down into a series of smaller problems: These can be solved more easily than trying to answer the complex problem directly. The same kind of approach should be taken in negotiation planning. We can break down a negotiation into several elements and deal with each element separately.

Every negotiation has these basic elements: parameters, bargaining range, motivation, position, style, and priorities. By systematically asking questions to research each element, we can gather a great deal of information that will help us be successful in a negotiation. In each element below, you will find remarks and questions that you should try to answer before you negotiate.

Parameters

Every transaction is defined by certain parameters that must be considered before a deal can be made. That means the negotiator of a deal has to think about those essentials before beginning to negotiate. Some of the questions that can help you consider the conditions that might affect your dealing are listed below.

- How does your financial condition affect your needs in this negotiation? What does your balance

sheet tell you about your finances? Can you refuse this job? Are you sufficiently bankrolled to hold out for a better deal?

- When will this work have to be done, and can I accommodate it? Are you so heavily scheduled that this job will overextend you? Can you shift a badly timed job to another day by offering an incentive?

- What resources (human, photographic, and financial) does this work require? Have you gotten a good understanding of what the job involves? Can you meet those requirements? If not, what can you do to supplement your resources to meet the requirements? Maybe you can team up with another person to combine resources. What is the buyer's budget for the work? How realistic is that budget? Has it been understated to induce you to keep your price down? Will their budget meet your needs?

- Where will the work be done? Is long-distance travel required? What will that do to your schedule? Is it likely to cost you other jobs? What will be the effect of that cost?

- How much preparation and post-production time will be needed? How many days will it take just to get the job? What fee is needed to cover those days?

- What is the buyer's payment history? Have you or any other photographer ever gone unpaid by the buyer? Do they pay promptly, or will you be financing them for months? Have you checked their credit and payment history with photographers and vendors? Can you find out from whom they buy office supplies or other items and call those companies' accounts receivable departments to learn the buyer's payment habits?

BARGAINING ISSUES

The substance of any negotiation is bargaining issues. These issues are the specific items that have to be negotiated to make a deal. They are not the same for every deal, but some of them are part of all deals. Major bargaining issues in photography deals follow.

- What price is the client expecting based upon local rates and fees? Is that a fair price for the work? Can you do the work for that price and meet your needs? If not, what price do you have to get to meet your needs? What price do you think is fair? How will you convince the buyer that your price is fair?

- What terms and conditions should apply to the job? Do film or digital files have to be returned to you? Will you seek indemnification from liability? Will you ask for a credit line?

- What rights are being sought? How long do they want the rights? What is the value of those rights? How does the value of the rights compare with their fee schedule?

- What rights are you prepared to sell? How can you get those rights to eventually revert to you? How much should you charge for all rights in perpetuity? What kind of schedule can you develop for various levels of rights licensed?

- What are the terms of payment of fees and expenses? Can some expenses be paid directly by the client? Can you get an advance on fees and/or expenses?

MOTIVATION

There is a reason for everything in business, or at least there is supposed to be. There is a reason why your client hires you, and a reason that you take some jobs and turn down others. It is important for you, as a negotiator, to understand the motivation behind your and your counterpart's demands. Understanding motivation allows you to construct alternatives to rejected offers and demands. These questions will help you arrive at motivation.

- Why have you been asked to compete for this work? Do you have a particular talent for the type of photography needed? Does the other

party think you might be less expensive than other photographers? Are you just one of many bidders?

- Why do you want to do this work? Is this the kind of job you want to do, or just one you will do for the money? How should your fee be adjusted accordingly?

- Why should you accept non-fee value? Can you get reprints or multiple copies of the final use for promotion, and what is that worth to you? Will this job increase your prestige or exposure?

- What is the buyer looking for in his supplier? What are the most important attributes (like artistry, quality, and delivery on time and under-budget) the buyer is seeking? How can you intensify his perception of you in terms of those benefits?

- What deficiencies do you have? Is there anything that you might say or show that would shake the buyer's confidence in you? What might he focus on as your weakness in this deal? How can you minimize the appearance of any deficiencies, whether perceived or real?

- Why does the buyer want the rights he is demanding? What alternative rights can you offer? How will those alternative rights reduce the fee?

- What kind of relationship exists between the buyer and you? What can you do to make the buyer want to work with you? What should you do to avoid alienating him?

- What could be the outcome of this negotiation? What is the best result that you hope to achieve from these negotiations? What would be the worst possible result for you?

Position

Each party in a negotiation will have an opening position on the bargain issues in question. The more that you can anticipate your counterpart's position, the better prepared you will be to deal with it.

- What do you want from this deal? What do you need from this deal?

- What does the buyer want from this deal? What does the buyer need from this deal?

- How far apart are each party's wants and needs?

- Where do your needs fit within the continuum of your counterpart's wants and needs? How can you tailor an acceptable offer to fit within your counterpart's wants and needs? What can you offer your counterpart to close the deal above your bottom line?

Negotiating Styles

What kind of negotiating styles are there? Negotiators have different styles. These styles fit along a line between "hard" and "soft." One person might be either a hard or a soft negotiator all the time, while another might switch styles from deal to deal or even within a deal. Still others will be in the middle of the two styles all the time. Being in the middle is a good place to be. Regardless of style encountered, you have to be able to recognize both, and to adopt either when called for. As part of your planning, you have to consider the style of the negotiator you will be facing. You may know this from past experience; but if this is not the case, you ought to try to find a colleague who has dealt with the person before. In the event you can't predetermine the person's usual style, you ought to be prepared for both.

The hard negotiator is like the aggressive buyer. He is usually very direct, makes no attempt to befriend you, makes difficult demands of you, displays a resistance to compromise, often speaks loudly, can appear to be a bully, and seems as unapproachable as a mother tiger guarding her cubs. He is quite prepared to intimidate you into accepting his deal, and he will work very hard to convince you that his deal is the only way the deal can be made.

The soft negotiator is your average salesman. He is usually very friendly, tries to befriend you, makes no demands but instead offers suggestions, pushes compromise to make the deal, has a friendly tone of voice, appears to be tranquil, and tries to make you think he is working in your best interest.

Some people have suggested that the best way to deal with an extreme negotiator, that is, one who is at either end of the spectrum, is to adopt the opposite style. Personally, I see no sense in

that suggestion. While negotiating is an attempt to balance positions, it is not done by counter-balancing styles. It is done through compromise and even concession, until interests are satisfactorily merged to produce fair treatment for both sides. My advice is that when you detect that a person is giving you a hard line or a soft soap treatment, you should adopt their style. Treat them in the same way they treat you. If you become a mirror of the way they present themselves, you will effectively turn the table on them by forcing them to deal with a person who presents just like them. What usually happens is that they quickly see that they have met their match, and then they usually shift slowly to a more moderate and middle-of-the-spectrum style. If you act opposite to their style, the hard negotiator will see you as dinner, and the soft negotiator will see you as unreasonable.

NEGOTIATING PRIORITIES

The priority order you establish in your negotiating plan can vary from case to case. In some cases you will want to settle the principle issues first. In others you will work on the position bargaining as a priority. The particular circumstances of any negotiation will usually indicate the priorities you adopt.

Perhaps you are going to negotiate a substantial job, which will involve significant expenses, such as payments for building and striking sets, models, interior designers, etc. You might find that the total of the expenses will exceed the fee for your creative services. Many photographers will only finance expenses to a certain point, because they do not want to tie up their cash financing a client's work. As a result, they have a

policy of requiring the client to pay directly for such expenses. In a situation where the expenses will be very high, and you are unwilling to fully finance them, you would plan to negotiate that issue early. Why? Because if you won't take the job unless some or all of the expenses are paid directly, there is no point in working to resolve different positions over rights and fees. The same situation might occur over getting an advance on expenses or a portion of the creative fee in advance. Here's an example: You feel that you must receive part of the fee in advance, either because you are concerned about the client's ability to pay your invoice promptly or because it is a new client, and you don't want to find them to be a poor payer *after* you deliver the job. Thus, you would first negotiate getting part of the creative fee in advance because, without that, all other issues are moot.

In each of the examples above you see a situation in which principles are as important as position. There would be no reason to expend energy and time negotiating the compensation for the deal if you have a potential deal-breaking policy to put on the table. If your policy is rejected, and you do not feel a compromise is in order, then the negotiation is over at that point unless your counterpart changes his mind.

Your priorities in negotiating your positions are usually governed by two simple rules: Resolve the easy issues first, and resolve the fees last. The easy issues might be how many days the shoot will take, when it will begin, and what the final deadline is. The more difficult issues are usually money issues, such as what level of contracted help, like assistants and stylists, are acceptable and what the reasonable expenses for the work are. The rights needed by the client are the next-to-last thing to negotiate, just before the fees, because the fees are usually tied directly to the level of rights to be acquired.

You cannot set a fee without knowing what rights you are selling for that fee, unless you are selling services only and giving away rights. In that case, you have broken the fair-value-for-fair-value rule of negotiating by giving away a valuable asset for free. The only company I know that did that successfully is Microsoft. It gave away Internet Explorer, its Web browser, in an effort to gain dominance in the field by destroying its competition. It worked. So, if you have the kind of financial assets that Microsoft has, you can give your rights away. But, if you do have similar assets, you ought to just shoot pictures for fun and start your own publication, design firm, or ad agency to use your photography. Don't put a photographer out of business when there are lots of bigger entities to pick on.

EVALUATING THE INFORMATION

As you assemble the information that will help you prepare some alternatives to offer the buyer, the process of evaluating begins. The answers to the many questions I've suggested in the preceding sections will begin to connect automatically. It is how the brain works. You feed data into the brain, which processes it in the background. It is much like making a spreadsheet containing formulas on a computer. You enter data, and the computer processes it. You don't see it processing, because it happens internally, not on the screen. The cybernetic functions of the human mind will begin to connect items that influence each other as you go through the list of questions and make answers. The evaluation of the data is underway as soon as you answer the first question.

The final step in evaluating is to get data on paper and to formulate some thoughts about your position. A good way to do that is to have an aid called a "homework sheet."

Homework Sheet

A homework sheet is a form, and it is a good device to help in making evaluations for a negotiation. It stimulates your thinking and helps you focus on important details of a negotiation. It is a tool that you will use when you need it. The more experienced you are at negotiation, the less likely you are to need it in situations that become everyday matters for you. The major components of a homework sheet are discussed below.

Negotiation Homework Sheet

Client Company: *This is the company that will pay you.*

End User: *This is the company that will pay your client. This part of the sheet is particularly relevant if you are selling your photography to advertising agencies, design firms, and other business that are acting on behalf of another party. This can often give clues to what the rights demand will be. For example, tobacco companies usually want copyright. Most international companies want the same. Local and regional companies don't need worldwide rights. A little research on the end user can be a big help.*

Client's Contact: *This is the person who contacted you. It might be an art director or picture editor.*

Client's Negotiator: *This is the person who you will negotiate with. It might be an art buyer or the person who contacted you.*

Client's Decision Maker: *This is person with the power to sign off on an agreement. It is not always one of the previously listed parties.*

Previously Served Client: *Is this is an existing or past account, or a new one? If it is not a new one, then look up what you have on file about this client.*

Local or Distant Client: *If the client is local, you might be able to meet with him to negotiate. While this takes more time than phone or e-mail, it is more personal and often more effective.*

How Client Learned of Me: *This gives clues to what a new client knows about other photographers in your area. If the client came to you on a recommendation, you already have an advantage. If the client found you in the phone book, you have no advantage.*

Description of Work Needed: *This defines the actual photography. It helps you decide the relative value of the images and of the client to your promotional efforts. Getting a call from NASA to photograph astronaut training has more promotional value than a call to shoot portraits of middle managers.*

Special Talent, Equipment, or Capability Needed: *This focuses your attention on what you have that another photographer might not have, thus giving you an advantage. If the job requires anything special and you have it, or if you can bring something special to the table, you may have an advantage over your competitors.*

Deadline for Photography Delivery: *You must know the drop-dead deadline in order to evaluate what time pressure the client is under to get the work done. You are not under*

pressure until you take the job. Time pressures on the client can give you an edge in the negotiation, because the client has to get the job underway and cannot waste time exploring alternatives.

Desired Shooting Date(s): *These dates could conflict with others in way to prevent you from doing the work. Perhaps you can offer an incentive to get dates switched to ones that you have available.*

Client's Special Concerns: *All clients want good photography at the right price. Many clients have a special need, such as a super-fast delivery, an assurance that the job won't go over budget for weather reasons, or a fear that the people to be photographed will be put off by all but a very sociable photographer. If you can determine the special needs, which are sometimes fears, you can pitch to them and gain an advantage.*

Client's Stated Budget: *This is what the client says is its bottom line when it comes to fees. It is a guide to estimating. You can then give both an on-target estimate, and an over-target estimate that allows for more or better work. Chances are that you will end up in between the two, meaning that budgets are not always what they seem to be.*

Rights Wanted: *These are the copyright rights that the client wants (but does not always need). "Rights Wanted" help you set the upper level of a fee structure—that is, more rights means higher fees.*

Rights Needed: *These are the copyright rights the client really needs to meet its goals. These are usually, but not always, less than the rights asked for. "Rights Needed" help set the lower level of a fee structure.*

Client's Payment Habits: *This is how promptly the client pays. If you don't know from experience, you can ask a colleague who has worked for the client, ask on an Internet list serve, or find out who supplies other services (janitorial, art or office supplies, etc.) and call those companies to make a discreet inquiry. Just call the client's switchboard and ask if the receptionist knows who the suppliers are.*

Competitors: *These are the names of the folks you are up against. If you know the names, you know just who and what you are up against. If they are all notoriously inexpensive shooters, you will know that you are unlikely to get the work at your reasonable fee. If they are all more expensive shooters, you know that either your fees will seem low (and that is not always good) or that you have an opportunity to earn more than usual.*

Competitor's Advantages: *These are the specific advantages that competitors might have, such as more experience, a more visible reputation, special equipment, capability, or facilities, or presently serving the client. The greater their advantage, the greater you will have to sell yourself, and the more competitive you will have to be.*

Your Advantages: *The other guy doesn't always have the advantage. Maybe you worked for this client, but with a different staff person—so you have a reference to give. Maybe the job needs three motor-drive cameras and you have them—so you won't have to rent them. Maybe you have special talent for shooting huge facility shots. Think about what differentiates you from the field and consider whether anything might be advantage.*

Your Rights Offer: *You know what the client wants. You have calculated what the client needs. Will you give into wants, or*

sell to needs? Maybe you ought to create three alternatives: one meeting wants, one meeting needs, and the other somewhere in the middle.

Your Bottom Line Rights: How useful will the photographs from this assignment be to you in the future? Is it possible to license it for reuse to the client or to others? Is it good for stock? Do you need the rights to use the photographs in your portfolio? Almost any (not every) image has some potential future value to you. Are you going to keep those rights or get paid for giving them up?

Your Fee Offer: This is the fee you will charge for the offer that you present. Generally, it is less than the amount you will end up receiving. If it is not lower, you probably under-priced yourself. Or you might be offering different fees based upon the three rights packages described in Your Rights Offer, above.

Your Bottom-Line Fee: This is the minimum amount that you can accept for whatever reasons—and the best reasons are that you will lose money if you go below that amount, or you just aren't up to providing super bargains for stingy clients.

Advance on Fees: Some jobs have very high fees at stake. If you don't know the client, or know it to be slow in paying, an advance of fees lowers your financial risk, but it also may give your competition an advantage if they don't ask for an advance.

Advance on Expenses: You might want this for the same reason that you want an advance on fees or because the expenses might be more than the fees on the job, and it is burden for you to carry them for the billing cycle. Again, you

have to weigh the financial risk against any possible competitive disadvantage.

Payment Schedule: *Maybe you can get the client to advance half the expenses up front, pay for the balance of expenses and/or half of your fee on acceptance of the images, and finally pay the remaining balance within thirty days of receiving the final invoice. Once the client sees the images, its photography-related risk is over. The client doesn't have to worry about receiving the images, so it has less of an excuse to withhold a partial payment.*

FALLING INTO PLACE

As you can see, the evaluation and generation of an offer and some alternatives fall into place as the process of filling out the worksheet proceeds. On some large jobs this process may take many hours. On small jobs it may take only a few minutes. Regardless of which, you ought to be thinking this way on all jobs, large and small. Whether you win an assignment and get an extra $5000 out of it, or receive ten assignments that provide an extra $500, the net increase in revenues is the same.

BEING THOROUGH

Like any process, planning for a negotiation requires thoroughness in the way that you approach it. Try to get answers to every question you can think of that might have a bearing on the negotiation. Become familiar with the many questions spelled out in this

chapter. Make up a homework sheet. Then practice with a few hypothetical job offers, or go back and look at a past jobs and see how a more thorough investigation and evaluation might have helped. Most important, apply what you have learned here on you next job offer. Negotiating skills are honed by practice, and practice should begin immediately and be continuous.

Chapter Four

Psychological Aspects

of Negotiating

The psychological aspect is an important part of negotiation because, as a mental exercise of wits, negotiation often involves things that affect our security. It also is a process that can require a person to exercise skills that they are unaccustomed to, and therefore are uncomfortable, using. The five psychological pressure points in negotiating are power, risk, fear, courage, and mindset. Having an understanding and command of those five pressure points is a big benefit in successful negotiating. I have borrowed the term "pressure points" because it has a special meaning in both emergency medical treatment and in martial arts. In the medical world, a pressure point is a spot where an artery runs close to a bone—pressing the artery against the bone can stop the flow of blood. Medical pressure points are used to stop life-threatening bleeding. In martial arts, pressure points are nerve centers where the application of force sends shock waves through the parts of the body fed by that center. Pressure points are used to disable an

opponent. Since the five psychological factors I have cited can either save or slay a negotiator with applied force, I think of them as pressure points.

POWER

By its simplest definition, power is the ability to act or produce an effect. As such, power is something we all want and have, but we don't all have it to the same degree. We know that others have more power than we have. It first becomes evident to us as children, when most people tower over us: We know that they are more powerful. Oddly, we are usually unafraid of these more powerful people, because we don't recognize the potential danger in them. As we grow older and begin to recognize that not all power is used to good purposes, we take care to avoid people who might use their power to harm us. At first, we deal with potentially harmful physical power by avoidance. Over time, we learn that in addition to physical pain, we can also experience psychological pain. We are already conditioned to avoid physically threatening power, so it is quite easy for us to adapt to avoiding psychologically threatening power. The world of business is full of power signs, which, if imagined to be threatening, can lead us to avoid them. Fear of power in business is a real handicap to successful negotiating.

Power is a factor in negotiating. It can be a deciding factor, because the most powerful person can usually win, if he decides to use his greater power. That is one reason why negotiating is not about winning but about compromising to achieve fairness. Power, as experienced in negotiation, must be understood—so that you can have a command of the subject. Fortunately, negotiating power can be analyzed and sorted into five categories, all of which are easily understood. We will now take a look at those powers.

Inherent Power

The two most common types of inherent power are financial power and official power. Just imagine that you won the lottery or were independently wealthy and did not have to work to support yourself. Without financial worries you could take any negotiating position you wanted to take, because your livelihood would not depend upon it. You would even have the power to be unreasonable without meaningful consequence to your financial well-being. But, if you are reading this book, it is unlikely that you are wealthy enough to not have to work. You live in the real world of the professional photographer. It is a world where most, probably all, of your clients have greater financial resources than you. In your mind, you realize that to some extent you are dependent upon their hiring you and transferring some of their greater financial resources to you. That makes them more powerful in your mind. The question becomes: What should you do in light of that realization? The answer is simple: Do nothing. It is a simple fact of life that some folks are richer than you are. So what. You would not be sitting and negotiating with them if they did not want something that you have. The need for, or desirability of, you and/or your services has placed you in a position of power. You have something they need and/or want.

Official power comes with company titles like president, chief art buyer, or picture editor. Often, we see titles as much more important than they really are. Remember this: In business, a title is only power within the company that bestows the title. The president of an ad agency can tell the vice president what to do, and she in turn can tell the chief art buyer what to do, but none of them can tell you what to do. If they want you to work for them, they have to negotiate. You are the president of your company. You may be the janitor too, but that does not alter the fact that you are at the top of the food chain in your company, and

you have to negotiate for your client's money just like they have to negotiate for your work. Official power should be insignificant in your mind in a business negotiation. In fact, it should be insignificant in any negotiation, because you *never* have to accept the dictates of the other side.

Fortuitous Power

Some power occurs by chance. Fate often hands more power temporarily to one party than another. Imagine two opposing army units at war with each other suddenly and unexpectedly coming upon each other. Chance engagements happen frequently in modern ground warfare. Suppose one army unit happens to be on the top of a hill when the chance meeting occurs, and the other happens to be at the bottom of the hill. Since holding the high ground is an advantage in ground combat, the unit on top of the hill has come by some fortuitous power in the engagement.

Photographers are often the beneficiaries of fortuitous power. It generally comes in one of two ways. The first is when timing is to your advantage, and the second is when you have an edge as a supplier. The best way I can explain each is with examples from my own experience.

At 6:00 P.M. one evening I was working in my East Coast studio when I received a call from the communications director of a West Coast shipbuilder. I had never done business with this company before, but I had sent them promotional materials in the past. Those promotional materials were photographs of ships in port in various situations. The communications director had a sense that I could do the job he needed. The company had a new ship that would be docking in the local port as its first port of call. The company wanted pictures of it as it came into port, docked, and was unloaded. When I found out that the commu-nications director had called me because of my promotional

materials, I realized that I had an edge on other photographers in the area, because it was very unlikely that any of them had done a niche promotion like mine and sent it to this particular company situated across the country. When the communications director told me that the subject ship was to arrive in port the next day, I realized that I had another edge. He didn't have time to start interviewing photographers. The job had to be awarded immediately. The deadline was working *against* the company and for me. I was the beneficiary of fortuitous power. I was, for all intents and purposes, the company's only good chance of getting what it wanted when it wanted it. I knew that my fee would not be as open to challenge as it would be if the buyer had a few days to find a photographer. In effect, I had no competition. And that took some power away from the buyer and gave it to me. I used it to get a higher price than my needs dictated.

Another instance was the sale of a stock image that I had on file. A publisher sought some images from me to consider for use on a cover of a horse publication. Within the selection I sent was an image of a teenage girl sitting on a corral fence gently stroking the face of a red-bridled gray horse. When the art director called, he told me that that particular image was not good for the application that he had requested the images for, but that it was "perfect" for the cover of the premier issue of a magazine for teenagers about horses that the company was going to launch soon. In effect I was told that I had the "perfect" cover image for the new application, for which the art director had obviously not solicited photos. This was empowering, because the buyer's perception that my image was "perfect" meant that it satisfied his wants, not just his needs, and by licensing my image immediately, many hours of future work could be eliminated. I could close the deal before any competitors knew about the opportunity, and I could use the buyer's opinion of my image being "perfect" to great advantage. I did.

Your clients have deadlines when they call you. You don't have a deadline until you accept a job. Time can frequently work to your advantage if it is putting pressure on the client. Your clients need a photograph, but they want a special or "perfect" photograph. If you happen to have the "perfect" one, you have not only what they need but also what they want. It is easier to get a person to pay more for a want than a need, especially when the need can be filled from more than one source. Timing of events and selections available are two factors that can empower you on occasion.

Competitive Power

Competition is a fact of life in business. Every business has competition, and usually tough competition—that is, competitors who will do almost anything to get the work that is being offered. Buyers know and use this fact to gain advantage in a negotiation. They know that competition is intended to keep prices in check, and that by emphasizing the competitive nature of the business they can not only prevent the price from moving up but also possibly even drive it down. It is quite common for a buyer to tell you that there are a dozen other photographers ready and willing to do the job. That is a veiled threat meant to instill fear in you. The buyer is simply tying to discourage any thought on your part of doing any more than meeting your absolute financial needs when pricing.

Let's analyze this kind of situation. This buyer who is warning you about your competition called you for a reason. It is possible that the buyer called you because he thinks that you are the only or the best photographer for the job. In that case, you have little, if any, competition, and competitive power isn't a real factor. It is possible that the buyer called you simply because he needs another estimate to satisfy the policy of his company to

have a certain number of bids on any job. In that case, competitive power isn't a factor, because you are not going to get the job anyway. What is most likely is that the buyer thought you would be able to do the job competitively—that is, at the same price that other qualified photographers would charge. In that case competitive power *is* a factor, but just how important a factor is it? In such a situation, all bidders would have the same power being used against them. The way you overcome the power advantage your client has is to differentiate yourself from the competition. What do you have that gives you an edge? You will have thought about this during the homework process, and you might find things that make you perfect for the job, or you might uncover buyer concerns that you can specially address in presenting your offer. When you read about commitment, below, you will have one example of how to differentiate yourself when no obvious tangible differentiation exists.

Competitive power is either not a factor in negotiating, or it is a factor that affects your competition just as it does you. In that case it is an equalizer: It does not make your competition more powerful. The problem is that the buyer is the one who will be empowered, if you permit it. To deny that empowerment to the buyer, you need only to ignore the fact that there is competition, and make your decisions based upon your bottom line on rights and fees. You never go below your bottom line, even when your competitor is willing to work cheaper than you. Don't let your competitors set your price: They might price you into bankruptcy. Ultimately, if the buyer doesn't want to pay your bottom line price, you lose the job. That's OK: There will be others that you won't lose.

Sometimes photographers can turn the tables on buyers when it comes to using competitive power. It works this way: When you are contacted by buyers, it is usually because they think you can

deliver what they need. The contacts themselves should reinforce your confidence, because you know that you are desirable in the buyers' minds. You can influence buyers' thinking by letting them know that they might have competition for your services—that is, you have other clients, and you are not dependent upon them. There are two ways to do this. One is to use the technique described below under The Power of Commitment, and the other is to let them know you are busy. When a buyer calls and asks whether you can come in to see him or shoot on a certain day, you can always respond with some hesitation by saying that you have something else planned on the date, but that you might be able to change it. It might be done like this: "I do have other plans for that day, but give me an idea of what I can do for you, and I'll see if I can change them." You have not lied to the client because everyone has something planned for future days even if it is not written down. You have simply told the buyer that you have things that compete for your time and interest, and he can't be guaranteed that you are available to him. Once a buyer has selected you as a desirable source, he is unlikely to want to lose that access. The fact that he is competing for your time can make him more willing to make concessions when you are the photographer he wants for the job.

The Power of Commitment

People are usually impressed by those who back up what they say with some sort of commitment. That is why warranties and guarantees are often used to sell products. Buyers are impressed by commitment. While I would never recommend that you guarantee the outcome of any photography assignment, I would suggest that you consider warranting the quality of your services when need be. When might you need to do it? Here is a possible scenario:

Your competition's pricing is being thrown up to you in attempt to get you to lower your price. You suspect that it is a just a ploy and that the buyer really wants to use you. You want to call him on it and give him a reason to accept your price. Here is the litany that I use in such a situation. "I know that some other photographers charge less than I do. I also know that there is a reason for that. In some cases it is because they do not have the required level of experience, or the right equipment, or they just lowball everyone. Experience is important to getting your job done on time and within budget; using the wrong equipment will have quality consequences; and a low-priced photographer is unlikely to be able to afford do this job right. You won't have those problems with me. Here is a listing of my clients with names of contacts and their phone numbers. You can call any or all of them. I will pay for the phone calls. If you can find one person who says that I ever failed them in quality of performance on any level, I will meet the lowest fee you are quoted and take off another 20 percent."

I have never known any buyer to call anyone on the list. I have never had to reduce my fee. I have closed many deals under competitive pressure by making a commitment that speaks to the hidden fears of buyers about missing deadlines, going over budget, or ending up with substandard work. Commitment works wonders in the face of competition.

The Power of Refusal

Refusal stops everything in its tracks. A final refusal in a negotiation stops all forward progress. No one can force you to make a bad deal for yourself. When the negotiation isn't going your way, when you see that the process is simply making a bad deal for you and you can't change that, then you are best off just saying "No, thank you" to the other party and withdrawing from the negotiation.

All deals are not good deals for all. You should never accept a job that doesn't meet your needs by going below your bottom-line position or policy. To do so is selling out to the other side. At that point, you are theirs, and they have no reason to protect your interests. It is your interests that you aim to protect and promote in a negotiation. No photographer ever went out of business by saying no to a bad deal. Many photographers have gone out of business by saying yes to bad deals. Say no, when you should and must.

RISK

Many photographers are averse to risk, trying to avoid it at every turn. The result is that risk plays heavily on their minds, and they are unprepared to take chances to improve their interests. The problem with risk avoidance is that it can make one too cautious by habit. There is some element of risk in every negotiation. Business is often called a calculated risk, because the level of committed resources can be managed according to the level of uncertainty of results. Negotiating, as a part of the business process, involves the risk of not meeting your needs by failing to negotiate a deal. The thought of failing to meet needs is a psychological stimulus that often results in feelings of fear, which I discuss in Fear Factor, the next subsection.

The size of the risk you can take is usually governed by two factors. One is the potential reward. Bigger rewards justify bigger risks, and vice versa. The other is your ability to survive the consequences of a high risk. Risk has to be measured by the actual dollars at risk to be evaluated. For example, if you were given the opportunity to pick a number from 1 to 10 and there was one winning number between 1 and 10, you would have one chance in ten of winning. Those are not great odds.

Let's suppose that you would get a ten-to-one payoff if you picked the right number. If you had to bet $1 minimum, your risk would be one dollar for possible winnings of $10. You would probably take the risk, because you can afford to risk a dollar. But what would you do if you had to bet $10,000 for a $100,000 payoff with the same 10 to 1 odds? You would probably decline, unless $10,000 didn't mean much to you. The two examples have the same odds and the same ratio of winnings-to-risk, but the *amount* at risk in the second example is ten thousand times bigger than in the first example. The inclination to avoid risk grows because the odds of winning have not increased with the size of the bet. You calculate that 10 to 1 odds are OK for a $1 bet but not for a $10,000 bet. Odds simply indicate the probability of winning. Risk should be evaluated on your ability to sustain the loss, should you lose.

In some negotiations you might not be able to move a buyer to accept your position. You might consider taking the risk of refusing to modify your position with the hope that your counterpart will give in. As a good negotiator, you know that you must enforce any ultimatum that you give, or you will not be taken seriously in the future, including the remaining part of the negotiation in which you are now involved. How do you decide whether to give the ultimatum or not? It goes without saying that when you declare a position to be non-negotiable (a take-it-or-leave-it demand), you are taking a risk that your counterpart will break off the negotiation. Before you do that, you have to be aware of the potential impact of the risk taken. You have to calculate the relative value of the job you are about to win or lose to determine whether you can afford taking the risk. If you are a very busy photographer and working regularly, you can afford to take a risk, because more work will surely come your way, and you have enough business to survive the loss of the job at

risk. If your business is marginal and you need every job you can get, you cannot afford to take the risk and ought not think of taking it. It would be a bad risk to take, because it could cost you dearly.

The level of risk we can take in most negotiations is dependent upon our financial strength and our ability to lose a sale without disastrous or seriously negative effects. So it is obvious that your success in a negotiation in which risk-taking is involved is dependent upon the strength of your business, and therefore it is dependent to some degree upon how well you have negotiated in the past and how much financial security you have achieved through those negotiations. It is another reason to learn to negotiate. The more successfully you negotiate, the greater your risk-taking capacity usually becomes. Understanding the nature of risk and the effect any risk might realistically have on your business will help you avoid feelings of fear, the enemy of any negotiator.

FEAR FACTOR

Imagine yourself in your office doing your work. Maybe you are paying bills. The phone rings. A client has an assignment for you, if the two of you can agree on the deal. You know you're going to have to quote and negotiate a package of rights and a fee. At this point, the realization that the job is not yet yours sets in. You think that you could lose the job, and your disposition changes accordingly from tranquil administrator to nervous negotiator. The checks you have been writing seem more financially burdensome than before. You don't want to lose this job, because that seems like losing money to you. You start to worry about losing

the money. The fear factor has kicked in, and you are at a disadvantage because your judgment is now based upon not losing, rather than upon getting your fair due.

Let's look at that situation in a slightly different light. Before the phone call you were not feeling insecure. During the call, you begin to worry about losing the job. What's wrong with that picture? One thing that is wrong is that you can't lose what you don't have. You have become worried about losing something you do not have. Losers think about losing. Winners think about winning. Good negotiators think about making fair deals. And, when they are unable to make one, they accept it as a normal course of business and move on to the next order of business.

Fear of losing, rejection, and financial insecurity are often irrational responses in a business situation. There are few, if any, situations in life—business or otherwise—that will have a catastrophic outcome if you are not successful in one brief moment of time. Still, many photographers seem to treat the award of an assignment as if it were a life-or-death matter. Let's face it, if your business is so shaky that not getting the next job is going to put you out of business, then you ought to shut down and re-evaluate what you are doing and how you are doing it. Until you do, you will be living from job to job, and fear will overwhelm you. Once you are overwhelmed by fear, your failure is almost assured. You cannot conquer fear by catering to it. You counterbalance fear by being courageous enough to do the right thing the right way. Knowing you are doing the right thing is uplifting, and doing whatever is right the right way is even more uplifting. So when you become fearful before or during a negotiation, and it happens to everyone sometime, you should just stay focused on your duty to yourself and the fear will subside as the courage rushes in.

COURAGE

Courage is defined as the mental or moral strength to venture, persevere, or withstand danger, fear, or difficulty. Since we are talking about negotiation, a mental process, we should see courage as mental strength. Mental strength comes from three things: knowledge, practice, and success. If you know how to negotiate, and you practice, then you will gradually succeed at it. You will develop the mental strength to courageously face any negotiating situation and your counterpart therein. You will see that you cannot lose what you do not have. You will also see that negotiating is about fair trading, not about winning and losing. You will understand the value of fairness, and from that you will have a moral center in your negotiations. With that accomplished, you will have both mental and moral strength and the fullness of courage that comes with them.

MIND-SET

Winston Churchill said: "Never give in, never give in, never, never, never—in nothing, great or small, large or petty—never give in except to convictions of honor and good sense." That is what I mean by mind-set: the mental strength to never give in to anything except when honorable convictions and good sense allow you to do it. The good negotiator perseveres in achieving a goal of a fair trade in which all involved parties feel that their needs have been met through a fair exchange.

Developing that kind of mind-set begins with having both the moral strength to not take advantage of another, even if you have the power to do it and having the mental strength not to allow yourself to be taken advantage of regardless of the power you face

or the fear you might feel. When you have the proper mind-set, you have harnessed the fifth psychological aspect of negotiating.

NEGOTIATING DISCIPLINE

An understanding of power, risk, and fear—coupled with courage and the right mind-set—will assure that you have the most important intangible qualities to be a successful negotiator. Power should not deter you, acceptable risk should not dissuade you, and fear should not overcome you. Mental discipline is a product of understanding coupled with the courage that comes from this understanding; and the strong mind-set that it is better to walk away from a deal than to settle for less than what you need. Negotiating discipline is what keeps the good negotiator on track and making fair deals.

Chapter Five

Negotiating Strategy

and Tactics

Many people see the words "strategy" and "tactics" as interchangeable. This common misunderstanding results in a failure to evolve a strategy, because most people think tactically. Strategy is the art and science of employing economics, psychology, politics, and force to accomplish a goal. A goal is usually composed of a number of objectives. Tactics are devices for accomplishing objectives. The good negotiator learns how to think strategically and act tactically.

Your economic assets are the state of your business and your financial health. You have learned how those things come into play in terms of taking risks. Your psychological assets are your understanding of and ability to use, and to resist the use of, the five pressure points we looked at in the last chapter. One definition of the word "politic" is "shrewdness in managing or dealing." Your political assets are derived from being a member of a business community. The more you learn about how that community of buyers and sellers does business, the more politic, i.e., capable of dealing, you are. Your

force is the energy that you use to guide the negotiation. Someone is going to gain control of the direction and timing of the negotiating process—it might as well be you. You can force direction and timing by how and when you make things happen in a negotiation.

Developing a Strategy

The first step in developing a negotiating strategy is to review the homework you have done as part of the planning process. In doing so, you look for opportunities to employ your economic position, psychological assets, political skills, and forcefulness toward accomplishing a goal. As you do your negotiating homework, among the many things you consider are certain economic factors. Among them are the client's budget and its flexibility; your financial condition, and whether it permits you to hold out for a better deal; and what non-fee compensation might be asked for in place of some portion of the fee. You also either anticipate or note the rights that the client will ask for as part of the deal. You have considered what rights you want to keep. You use that information to form a goal.

Let's say that you decide the following:

1. The client's budget probably has some flexibility.

2. The client will ask for the copyright to the images that you take.

3. Your finances allow you to pass on this job if you can't make a good enough deal.

4. The images have no value as stock photography, and the likelihood of client reuse is very slim.

5. The images will have little promotional value because they are too niche oriented.

6. The job is suitable for using the end product as promotional material because it promises to be a high-quality piece that stands out for its design, materials, and use of the images.

SETTING GOALS FOR THE NEGOTIATION

The next step is to formulate a goal for the negotiation. Using the above criteria, you might decide to try for the following deal:

1. Ten percent more compensation than the client has budgeted.

2. Rights limited to the end product(s) that are already on the table (let's say a brochure and a trade ad).

3. Trade-ad use limited to not more than one year.

Let's analyze this negotiating goal. You want 10 percent over the announced budget, but 5 percent under it will meet your needs. You have no real need for the images other than for this job. Even though you don't need to retain the rights for your future use, you are not going to sell the copyright for less than double the client's budget. You know that the finished brochures will be special and could help you promote your business: They will be slick and will make fine use of your images, so you can profit by the impression they can make on other prospective clients for brochure photography.

Let's say the client's budget for photography is $5,000. Your wants-to-needs range is $5,500 to $4,750. Let's also say that you have found out that the brochures will cost the client about $1.00 each, and you estimate that a substitute promotional item would cost you at least $3.00 each, so you set a value of $3.00 on the brochures as a barter item. Finally, you know that rights will be an issue, so you decide to provide the client with alternatives. The copyright will cost $10,000. The brochure rights and trade-ad rights for one year will cost $5,000. You will offer a third option, which will offer an additional year of trade-ad usage for $7,000. You have set your rights and fee goals based upon the economics as you see them. Here's your negotiating position so far:

1. You will refuse the job if the client will not compromise on the demand for a copyright or pay $10,000 for it.

2. You will accept $5,500 plus 500 brochures (a $1,500 value to you) if the client will not pay $7,500 in cash for the package that you offer.

PSYCHOLOGICAL CONSIDERATIONS

During your homework analysis, you realized the following: This job is on a very tight deadline; you know the client is really concerned about missing the deadline, because he is asking a photographer to work very fast, long, and hard to get it done; the fee is not exceptionally high. You take the time to recall the details of two other jobs that have required a real stretch on your part. You note the names and phone numbers of the contacts on each of those jobs. You will give these to the client to motivate him to use

your services by reinforcing your commitment to meeting the requirements of the job. You are essentially acknowledging your client's fears and showing your commitment to easing them.

POLITICAL INFLUENCES

From business experience, you know that some photographers are prepared to sell the copyright to their images for less than the client's budgeted amount. You have already decided not to sell the copyright for less than $10,000, an amount that will most likely disqualify you if you cannot convince the client to compromise. You also know that the client knows that you are not one of those photographers who sells all rights for any amount offered. Still, the client is talking to you, so that means he is probably receptive to some compromise. You have to have an alternative position to propose should it become necessary. Most advertising clients want some level of exclusive and unlimited use for their money. Understanding that, you come up with your bottom-line offer in terms of a liberal grant of rights.

If the client will not accept any of the rights/fee options that you present, you will propose an alternative that requires both of you to compromise your positions: You will provide eighteen months of unlimited and exclusive use for $5,500 plus 1,000 brochures. If he presses you, you will give twenty-four months of use, because the fact is that most ads don't run for more than a year, let alone longer. The value to you is $8,500 ($5,500 in cash plus $3,000 in promotional material). The cost to the client is no more than $6,500 ($5,500 in cash plus the cost of the extra brochures, which at top price cost $1.00 each). Your client has to stretch his budget by $500, and you have to surrender some rights to images that you already know will have no stock photography potential and are not likely to be reused.

FORCEFULNESS

The only way to gain control of the direction and timing of a negotiation is to take the initiative, state your case first, and let your counterpart deal with it. Otherwise, you are dealing with their initiatives, and that can put you on the defensive. The last thing you want to be doing is shooting down their suggestions. It is better that they shoot at yours. That way they don't get offended that you don't like what they have to say, and your psychological grasp of the negotiating process makes it easy for you to understand that your ideas will be shot at and some will be shot down—but you know this is part of the process, so you will not take offense.

You then formulate what will be your opening pitch as you present your offer. Thinking about the previously mentioned stratagems in light of the negotiating principles you understand, you decide that you will address the parts of your offer in the following order and for the following reasons.

First, you will start by telling the client that you prefer to not sell the copyright; but, if he insists, the fee will be $10,000. (Remember this is a deal breaker—a principle to bargain, not a position.) Second, you offer the three options you initially developed. You present the copyright-for-$10,000 offer first, because there is no point in going forward to the options unless the client understands this is a take-it-or-leave-it copyright-transfer offer. If he takes it, you get what you wanted. If he rejects it and is prepared to entertain your three options, he has taken a giant step away from his wants and is moving toward his needs—which is where you want him to focus. Third, and only if none of the other options are moving toward acceptance, you present your alternative offer of unlimited, exclusive rights for a limited period of time.

The tactical means to implement your strategy will become clear to you later in this chapter. What is important to understand now is that you need to practice your pitch so you do not stumble as you make it. Part of taking control is to have a commanding presence—that is, to act authoritatively. Commitment and resolve are as much expressed by one's stature and voice as by one's words.

TACTICAL NEGOTIATING

Tactics are devices for accomplishing objectives, and there are many such devices available to the negotiator. Every skilled negotiator uses tactics to improve his or her position in a negotiation. The need for some tactics occurs when a negotiation bogs down and the parties are stuck on an issue. Other tactics are part of every negotiation. The most useful and appropriate negotiating tactics are easy to grasp and employ.

Look Confident

Look the prospect in the eye when you're talking. Stand or sit up straight. Don't lean up against the wall or hang your head down like you need support. Look confident. Speak with a strong voice. Slouching in a chair, leaning over a table, or burying your head in your hands can be seen as signs of weakness. Just as talking too loudly is a sign of aggressiveness, talking too softly is seen as a sign of weakness. Avoid any behavior that makes you look less than absolutely confident that your position is sound, correct, and to be adopted by all.

It is especially important to look your best and confident the first time you meet someone. A person's basic opinion of you is formed in the first thirty seconds of a meeting. If you make a bad first impression, it can take years to correct it. Look successful. Wear

neat and unworn clothing. You don't have to look like a Wall Street banker. Just look like a successful photographer-businessperson. People are attracted to success. Looking successful contributes to making that impression.

Be Clear

Say what you have to say clearly, and don't send out confusing signals. For example, if you don't like a prospect's offer, and you have an alternative as a counteroffer, say, "No, I can't accept that, but I have an alternative." If something is unacceptable, it's simply unacceptable, and that is OK in business. Don't try to sugarcoat the fact that you won't accept something. Doing so can make the prospect think that you might give in if they hold fast. It's better to let them know where you really stand and how firmly.

Ask Why

If you are presented with a demand that you cannot accept, rather than rejecting it immediately, it is better to ask why such a demand is being made. Then, using your good listening skills, take in the reasons for it. Understanding the reasoning behind a demand is the key to being able to create an alternative. If the answer you receive doesn't answer the question, simply point that out. This most often happens when a prospect answers your question with something to the effect of "Because my client wants it." Indeed that may be true. But the next question from you has to be why his client wants it. Unless you know the reason for a disagreement, you cannot resolve it. Once you know that reason, you have a chance of resolution. If you don't get the answer, diplomatically repeat the question again, stressing how important it is to you to understand why a party wants something, so you can try to understand why you should agree to it.

Be Silent

After you ask the question why, be silent and wait for an answer. Listening is active. Hearing is passive. You cannot turn off your hearing. You can't listen while you're talking. Your silence also places all the pressure on your counterpart for the moment. You have asked a reasonable question, and he knows you are entitled to a reasonable answer. If his demand was more bluster than need, the prospect may be unable to give a good answer. This often results in his being more prepared to compromise, because you have shown him the weakness of his position with a simple tactical question followed by a silent demand for an answer.

Broken Record

This tactic amounts to repeatedly asking for what you want until you get it. My favorite occasion to use this tactic was when asking for an advance on expenses, which I did anytime the expenses on an assignment would be over a certain amount. I'd start by making a unilateral assumption that I would be getting the advance: "Of course, I'll be billing you for half the expenses in advance of the job since they are so high." If the reply wasn't "OK," I'd restate my demand differently: "The expenses on this job are really high. You are asking me to tie up a lot of cash on this job until I get paid. I really need an advance on the expenses." If I got another rebuff like: "We don't customarily give advances," I'd reply with "I appreciate that fact, but I need an advance on this job. I am asking you to make an exception. Fifty percent is reasonable. Isn't it?" Of course you can push a good thing too far. If the broken record is starting to annoy the prospect, turn off the player—that is, drop the demand unless you cannot do the job without the advance. In which case, keep the record playing.

Bold Response

Prospects can try to back you into a corner in a power play. The most common is the threat to use a competitor unless you agree to the prospect's terms. Knowing that this is usually a bluff, a good way to deal with it is to simply call the bluff. Perhaps your client says, "Your competition will do this job for half your price." You can try a reply of this sort: "If you really don't think I'm the right photographer for this job, I'll be happy to step aside. I know I'm the best person for this job, but if you don't agree, I can't argue with you. If you want to use my competitor, it is your option, but if you want to use me, we have to come to terms."

Trial Balloon

This tactic is used it to test the waters without putting your client on the spot. For example, "What would you say if I told you my fee for this job was going to be $3,000?" Another example of a trial balloon is "How would you feel if I asked you for all the expenses in advance?" You have presented a "what if" question. By doing so, you minimize the risk and leave yourself a chance to recover from a rejection. You haven't presented it as a demand, but rather as a test. If the reaction is favorable, you can adopt the position. If the reaction is unfavorable, you turn the table by asking something like "You obviously have a number in mind. Tell me, what do you think is a fair fee?" You test your position without standing firm. This gives you the opportunity to back down without looking weak.

Use Candor

Candor is an excellent tactic that fits neatly into a time when you need to bring a negotiating discussion that has been going in circles to a conclusion. For example, let's say that you have been haggling over usage and fees with neither side giving ground. The

discussion is going nowhere. You might say something like this: "I appreciate you want to hold to your position on the copyright transfer you have asked for and the fee for this job, but I simply cannot accept it. I really believe that the quality of my work and the reliability of my service are worth more than that. I do want to do your work, I really do. But I cannot undersell myself to get it. It isn't fair to me or my other clients who paid my fees in the past or will pay them in the future." You can follow that up with a compromise offer in a trial balloon. You immediately segue into something like this: "How do you feel about a compromise that gives you unlimited, exclusive rights for three years with a fee that is 15 percent less than the fee I proposed for the copyright transfer?"

You haven't demanded that switch. You haven't taken the debated propositions off the table. You have expressed your point of view candidly, and offered a compromise. That is, after all else is said and done, what negotiating is all about.

Nibbling

This tactic is employed *after* you've made the deal and have the job. You might come back at the prospect-turned-client and say something like "How would you feel about giving me half the expenses in advance on this one?" If you get no for an answer, you have not jeopardized getting the job. If you get a yes, you have an advance.

Optional Offer

An example of an optional offer can be something on this order: Perhaps you are negotiating for an assignment that requires models and a stylist in addition to the routine material and other expenses. You have asked for an advance, only to be refused on the basis that the company frowns upon making any payments to photographers until after the work is accepted. You are facing a substantial layout of capital for models and a stylist, so you are

not prepared to give up some sort of advance—but the prospect is unwilling to write you a check. You propose an option to replace your demand for an advance. The option is that the prospect will pay the modeling agency and stylist directly, thus reducing your cash layout for the expenses. It is just as good as an advance to you, and it does not burden the prospect, because he will not have to pay the agency and stylist until after the work is done.

Trade-Off

The heart of a trade-off is a conditional exchange of demands— if you will give to me, then I will give to you. This tactic is a more common in multifaceted negotiations, like those involving labor contracts, than it is in sales. But still, you may have an opportunity to use it. Here's an example. You have the good fortune to be the only photographer that the prospect can use on the assignment in question. Maybe it's because the prospect just doesn't have time to explore other options, or maybe it is because you are so uniquely qualified or equipped for the job. You have demanded a credit line with the picture and the prospect has absolutely refused to give it. You also want two days to do the shoot. The prospect is pushing for one day but has not absolutely said no. The prospect says no to the credit line, because its client isn't going to allow it to appear in print that way, and the prospect knows the client will never change that view. You know that. So you offer a trade-off. You will drop the demand for a credit line if the prospect will pay for the second day. You know that the prospect can get the extra money, while they cannot get the credit line approved.

Red Herring

Herring are fish that are a mixed gray and white color. Smoked herring turns reddish in color. In negotiating, a red herring is a demand that has been put up as a smoke screen. It is a demand

that you make even though you will not be able to get it. Why would you do that? So you can trade it off later. In the example of the trade-off in the paragraph above, your demand for a credit line was a red herring. You knew you would never get the credit line.

TINSTAFFL

This mnemonic device helps you to remember the fact that There Is No Such Thing as a Free Lunch. In business, you get what you pay for and you pay for what you get. I used to carry small cards like the one below. Whenever a prospect was pushing me to do the job for less money than a job was worth I would introduce her to TINSTAFFL. I even had a business card printed with that mnemonic printed on the back.

The prospect had a few seconds to absorb the message, I would chime in with "If I did the job for the price you offer, I would have to cut back on service or quality. This is an important job for you and me. Neither of us wants to sacrifice quality. I am in a business just like you are. I can only give what I get paid, and you can only get what you pay for. Cheaper isn't the way to get better. Nothing is free."

Positive Priming

There is a technique for conditioning people to say yes, which is a word you normally want to hear from your counterpart in a negotiation. The method is really very simple. You ask a series of questions or make a series of statements that will get a positive response in an answer or in the person's mind. Here's an example monologue: "I have a reputation for not only delivering fine quality work but also for getting it to my clients on time and within budget. I'll be happy to provide you with a complete client list as references, if you want to verify what I said. Obviously, you'll want us to continue that record when we work for you. I suspect your deadline for the

photos is a firm one, isn't it?" (Answer: "Yes.") "Would you feel better if I placed this job a few days sooner in my schedule to assure no delays will interfere with meeting your deadline?" (Answer: "Yes.") "If you can assign this job to me today, I can work it into my schedule very soon. Here's what I have to offer. We can do this job for $5,000 plus expenses. We'll have it wrapped up in two days. Do you want us to shoot on Tuesday or Wednesday?"

First you established a positive line of thought, and then you asked two "yes" questions. Finally, you assumed that you would be doing the job and asked them what day they would like you to shoot. Don't just ask, "Do I have the assignment or not?" Make the assumption that you have it. Don't ask a question that can get no for an answer.

Funny Money

This tactic is used to demonstrate to your client that an offer is laughable. Suppose an editor says, "We pay $200 for a job like this." You say, "Wow, I'm spending two hours to come here to see you and return to my office. Then I need two hours to get equipment prepared and travel to the job. Then I'll have two hours of shooting followed by two hours of return travel and trips to the lab. Add two more hours to edit and deliver the images, and not counting the administrative time to invoice the job, I'll spend a minimum of ten hours to meet your needs. That comes to $20 an hour. You show me a photographer that can stay in business making only $20 an hour, and I'll show you a fellow who is soon to be bankrupt or who is independently wealthy. I need at least $600 for the job just to break even."

When you break the money down to understandable units of time, you show the client how the money doesn't fit the time and effort involved. Always be prepared to present just how laughable an offer is by offering a detailed analysis.

Flinching

This is a tactic that should be used sparingly, and it is usually used in combination with another tactic, such as Bold Response and/or Funny Money. Basically, a flinch is a visual cue intended to provide a clue. For example, picture yourself sitting across a table from your counterpart with your hands folded and resting on the table in front of you. The client makes a ridiculously low payment offer. You respond visually by pulling your hands up off the table and separating them, and then by placing them back on the table by lightly grasping its edge. At the same time you exclaim in a firm (not loud) voice: "That's totally unacceptable. I am going to have to pay my assistant that much to help me on this job. I can't afford to work for assistant's wages. I'm long past that stage of my career."

You rejected the offer with a bold response and candor, while declaring it almost laughable and at the same time reinforcing your message with a gesture of despair, i.e., flinching. That happens to be four tactics rolled into one package, illustrating how tactical methods often combine well.

Good Cop/Bad Cop

If you have ever seen a detective film with an interrogation scene in it, you have most likely seen the tactic when one cop leans hard on the suspect trying to break him, and then another cop eventually steps in and "rescues" the suspect from the hard-line treatment.

This is a tactic that is used by buyers on occasion. You have probably experienced the negotiating situation in which your counterpart blames something you don't like on another person. Often it's the lawyer who insisted that they purchase the copyright to all photographs shot on assignment for the company. The good guy is talking to you and the bad guy is leaning on you. Of course,

the bad guy isn't present. In such a situation you ought to insist on talking with the bad guy. You cannot negotiate without one of the players involved.

Good cop/bad cop is also a tactic that you can use in some situations, if you have a partner, studio manager, or representative. You and your rep agree that he should drive the hardest deal possible to condition the client's desire for some relief. Your representative and the buyer reach an impasse, but the job meets your bottom line. The rep is pushing to get a fee that the client is resisting. You say to your rep, "I wouldn't normally do this, but we haven't done much work with this client, and I really want to show them what we can do on a big job like this. I'm going to interject here and say we'll do it for the client's offered price."

You became the good guy and used the tactic to avoid the impasse and get the job. One thing you must remember is that both you and your negotiating partner have to have previously discussed the use of this tactic. The last thing you want to do is surprise your partner.

Reverse It

You will recall that one characteristic of good negotiators is that they are empathetic. Empathy is an understanding of the experience of the other party. You can reach out to the empathetic negotiators by asking them to reverse situations in their minds. Ask them to consider what their reaction would be if they were in your place.

An example of reversing can be developed around the example of the funny money tactic mentioned above. You were offered $200 for what ought to minimally cost $600. After pointing out the differences in positions, you could say something like this: "What you are asking me to do is work for one third of my usual fee. I can't afford to do that. Suppose your boss came to you and asked you to reduce your salary by two thirds while you work on this job.

Would you do it? You know you wouldn't do it, and you shouldn't do it. The value you bring to the work doesn't change with the work, so your pay should not change either. Well, that is exactly how I feel about my fee for this work. I am sure that you can see it from my point of view, so can we talk about a reasonable fee?"

Appealing to their sense of empathy, you asked them to imagine the same kind of thing happening to them, and then you asked for fair treatment. It is hard to ask a person to give up what you wouldn't give up. Reverse that on your counterpart and you might just move them closer to your position.

Challenge for a Change

This tactic is nothing more than confronting what is presented as a nonnegotiable position. It is also used to attempt to get a negotiation started when you are told that your only choice is to either accept or reject the client's offer.

Should you accept the fact that a deal is take-it-or-leave-it, just because someone says it is? No, not until you challenge it. What you might say is "I think that you are being unfair. Let me ask you a question: Do you think that the best way for two people to make a deal is to make one that is fair for both of them?" If the person says no, he's saying he doesn't believe in fair dealing. Let's assume he says yes. You could reply, "I'm really surprised, even though I know you think your offer is fair. You're not giving me the opportunity to explain why it doesn't meet my needs. Allow me to explain why that's so, and what it would take to make a deal within the parameters that allow me to do this job. Then we can finish this meeting knowing we both tried to be a fair."

Your challenge might be futile. Some people refuse to negotiate. If you can't force a negotiation, then evaluate the deal based on what you're being offered and what your needs are. If the offer meets your bottom-line needs, take it. If it doesn't, leave it.

Limited Authority

In some business circles, limited authority is becoming a way of life rather than an occasional tactic. When your negotiating counterpart does not have the authority to make a deal, his authority is limited. He is messenger to the person who has the proper level of authority. He takes your offer to someone else who decides on it. If it is refused, as it often is, you have to rework your offer and present it again. In effect, it is a way to force your position downward. It is not a good position to be in and ought to be avoided. To find out if a person has limited authority, just ask if he is empowered to approve and to sign off on the deal.

You should ask to meet with the person with authority, because only you can convey your message the way you want it conveyed. However, you probably won't get what you ask for. In that case, you should make your offer conditional by reserving the right to change it or withdraw it at any time. That way you are negotiating on the same ground: You have not made a solid commitment.

INTIMIDATION SWEEPING

Intimidation is like having mines in the water where you are sailing your ship. You know they are there, but you don't know if you will strike one, or whether it will go off if you do strike it. Mine sweepers are ships used to clear minefields by sweeping the water to drag the mines out of the way so they can be safely exploded. Intimidation is like a minefield. The danger is there, but the level of risk is unknown. You have to sweep the intimidation away in the rare case that you might encounter it.

Intimidation is a tactic used by some buyers. What do you do when you see that someone is trying to intimidate you? I can answer that by example.

Years ago, I was doing a great deal of corporate work for different communication departments within a large teaching hospital, such as those in the medical school, the nursing school, the research center, and the hospital itself. One day, I could not resolve a difference in positions with one of the communication directors. I had the experience and the equipment needed to do the work best. I knew I had little, if any, competition. At some point I made it clear that I was not going to lower my price, because I thought it was more than fair in light of the fact that I couldn't think of a soul who was better equipped to do the job. The communication director didn't like my answer. He said that in that case I was going to lose the job. I acknowledged this and said I was sorry to hear it, but it was his choice and I respected it. Then came the bombshell. He said that he might feel compelled to tell other communication directors in the hospital about how difficult I had become to work with, and that could cost me more work.

My reaction was swift and soft. I calmly said, "I have confidence in two of my beliefs. First, I believe that any communication directors connected with this institution will know that to be false, just as you know it to be false. Second, I believe that since you know what you said is not true, and since you are a decent person, you would never do such a thing."

He immediately apologized and offered that the stress of the past days had gotten too him, suggesting that we pick up tomorrow to see if we could resolve the matter. What I did was reject his intimidation attempt, explain why, and excuse him. He knew I wasn't going to be intimidated, and I didn't have to make threats to protect myself.

Suppose he had responded to my polite rebuttal by telling me that he had every intention of carrying out his threat. I would have told him I was going to put the hospital's legal department on notice that he was threatening to blackball me to intimidate me to

drop my price; and, if he ever did blackball me, the hospital could expect to hear from my lawyer. I would also refuse to quote any more jobs for him, to prove that I was not simply bluffing. I would have suggested to him that he had better be sure that all the other communication directors liked him better than they liked me, because it would only take one of them to back up my report, and that would put him in real hot water for making an illegal threat. The reason I would do those things is simple. Who needs a client like him? Never submit to intimidation.

FIRE A LIAR

Fortunately, it is a rare situation to encounter a liar in a negotiation. When I speak of a liar, I am not referring to a person who occasionally uses an inconsequential lie, sometimes called a white lie. I am talking about the liar who will deceive you into seeing things his way.

Unfortunately, you rarely find out that you have been deceived before it is too late. In some situations, you might be able to take action if the lie ends up costing you something tangible—like money. The probability of taking a loss is decreased if you keep notes of your discussions and agreements and lay them back to the client to avoid the consequences of a failure of memory (see chapter 6, under the heading Be Thorough). I also advise that you should confirm the important points of your deal in writing. While most people won't deceive you, some will try. The more you show them that you have a record of what is taking place, the more you motivate them not to try it on you.

However, it is almost impossible to escape victimization by an accomplished liar. If you know a person to be liar from experience or other evidence and testimony, the best course of

action is to refuse to engage in any activity with him, including exploratory talks about a job or purchase. The accomplished liar can always get the best of you, because he not only does not strive to be fair, but he is also intentionally unfair. The only defense is to avoid him. Just as you would fire a dishonest employee, you should "fire" a dishonest buyer or seller by refusing to do business with him.

MISSING LINKS

There are two reasons photographers fail to negotiate deals that are better than the ones they are first offered: 1) failure to formulate a negotiating strategy, and 2) ignorance of negotiating tactics. Photographers who fail to get better deals often say that their clients won't negotiate. What they are actually saying is that they failed to begin a negotiation because they failed to think about negotiating or failed to learn how to negotiate.

By developing a negotiating strategy, you take the first step toward initiating negotiations. That first step gives you a direction, an approach, and a goal for the negotiating process. Once the negotiation begins in earnest, the wide variety of tactics available to you enables you to present and promote your position, while moving your counterpart closer to your position. Don't have any missing links in your business efforts. Failure to negotiate is a missing link, and a missing link means the chain is broken.

Chapter Six

Negotiating

the Assignment Deal

Of all the negotiating challenges a photographer encounters, negotiating an assignment deal is usually the most difficult. I am not saying it is difficult by nature. I am saying that the negotiation of an assignment deal is more difficult when compared to negotiating a stock photography sale. The reason I say this is because you are negotiating a price for something that does not exist at the time of the negotiation. You are negotiating for the opportunity to make something exist. Unlike a stock photography sale or the purchase of a camera, the assignment's tangible product, the images exist only as concepts— until after the work is done and the photographs are made. In other words, the buyer does not know exactly what she is buying.

INTANGIBLE FEARS

Take a moment to think about buying stock shares in a company. You are buying a piece of paper that has an assigned value on the day you buy it. This value is based upon many factors, including the emotion driven, fickle stock markets of the world. You could pay $100 per share for a stock on a Monday, and it could drop in value by 50 percent by Friday. While you hope that your research into the company whose stock you bought will protect your investment, you realize that there are factors beyond your control that can affect the value of any stock shares that you buy. One major factor is the performance of the company issuing the stock.

An assignment's outcome is dependent, in the first place, upon the performance of the photographer. A complex assignment may also be dependent upon the performance of several other people under the photographer's control: Assistants, stylists, models, set and location preparers, and others might be involved in making the assignment a success. The buyer is taking a risk based upon your company's performance.

PERFORMANCE ISSUES

Place yourself in a buyer's shoes for moment. You are selecting the photographer to make images for a $50,000 regional advertising campaign for a lawn care service. Lawn care is seasonal. Advertising has to be properly timed for the selling season. Media space has to be reserved and lots of work has to be done before the first ad appears. Much of that work has to be done in advance of the photography, because the images to be made will depend on layout and copywriting considerations. Now you know why

photographers are called last. The fact is that the creative agency and its client are going through a process that ends up with the photography being taken near the end of the project. That fact increases pressure on the buyer and can make him very concerned about the outcome.

The buyer's concerns are meeting the deadline for the photography, achieving hassle-free and acceptable quality of service in addition to high-quality photographs. Add to that list the fact that the buyer needs it all done within budget, because no one likes to go back and ask a boss or client for more money—it is not good for job security or client retention. Your buyers worry about staying within the budget. The performance issues are timely delivery, quality of service and photographs, and budget.

If you reflect on the previous chapter, you will recall that these performance issues are to be considered in the strategy formulation for your negotiation. You will also recall that some tactics are natural fits for performance issues. Tactical commitment—that is, offering proof that you can meet all the performance demands of the work to be done—is a natural fit for dealing with performance issues. It should be included as part of your sales pitch in any attempt to secure an assignment when the client is not aware, by personal experience, of your ability to perform. Remember, every photographer seeking the assignment will show a client list and a number of tear sheets to prove his capability. However, those things do not speak to performance in a totally convincing manner. Who knows what horrors were encountered in the photography phase before the job went to print and produced those nice tear sheets. The tear sheets and client list do not indicate whether the job was done within budget and on time. They do not indicate whether any re-shooting was required. They don't tell whether extensive work had to be done on the photographs to correct problems. They only show what the final ad looked like. Of course,

your portfolio photographs will speak to your proficiency and artistry as a photographer, but consider this: All buyers know your portfolio contains the ten to twenty best shots you have taken in the past few years. They know your portfolio does not contain any work that was less than best for a buyer's eyes.

A list of satisfied clients with contacts and phone numbers is a great testimony to your performance. The mere fact that you offer such a list demonstrates that you have confidence in your performance. Confidence is contagious—help your client catch it. Deal with performance issues head on and set her mind more at ease than your competition will. When you do this, you will have positioned yourself for a successful negotiation of the remaining bargaining issues.

Finally, it never hurts to replay your message about your performance capability. While not being a broken record, mentioning your commitment to performance at critical stages when dealing with the value issues can only help you in the client's mind.

Value Issues

In addition to the performance issues mentioned above, you need to focus on value issues. The three main value issues in an assignment negotiation are time, usage, and materials. Time influences the fee for you and your support personnel. Usage is the copyright rights required to permit the client to use the photographs. Materials involves the expenses and costs (including your overhead) related to the job. Every assignment has these three components. Each one of these value issues is thoroughly addressed below.

What this book does not cover is how to arrive at the value of your time, expenses, or copyright rights granted. Those are business

matters and are outside the scope of this book. If you need to learn more about arriving at appropriate value for these items, you might want to read my first book, *The Real Business of Photography*, published by Allworth Press, the publisher of this book.

TIME

You have undoubtedly heard the saying "Time is money." In business that is a true equation. Another thing is true about time. It is the only thing you are sure to eventually and permanently run out of, and that makes it extremely valuable. You charge a fee for your time. That fee is negotiable, as it should be. Your negotiating success will set the value of your time. It's that simple when it comes to time you are selling. But there is another aspect when it comes to the value of time in a negotiation. Some time is more valuable than other time. Let me explain.

There are some days in everyone's working schedule when the workload is lighter than other times. If you can shift workload from one time to another, it can mean that your earnings will increase. An example of this concept follows.

You are called to provide a quote on an assignment that the buyer wants to shoot on a certain day—let's say a Tuesday. It happens that you are already committed to shoot on that Tuesday. That means you lose the job unless you can shift the day that one of the jobs is shot. It is difficult, and may be unwise, to postpone scheduled work. Clients generally do not like to change schedules, and doing it to shoot another job for a different client is like telling the original client that her work is not as important to you. A more successful approach would be to time shift the work of the client who is offering the new job. Shifting the time will allow you to make money that you

would otherwise not receive. You might consider proposing a discounted fee if the job being offered can be shifted to a different day. This does not mean that you should discount the overhead or materials. That would be like throwing away your money. Time shifting is all about getting money that you might otherwise not receive.

Time shifting usually comes into play on smaller, routine jobs. Big productions usually have to be planned well in advance, so they are normally scheduled for available days. Less complicated jobs, like a facility shoot for a brochure or a product shot for a small ad, are more likely candidates for time shifting. These are jobs that don't usually require lots of time calculating the price. You routinely know what you charge for them. So you can give a price early and quickly.

Offering a time-shift discount is simple to do. You simply discount the time by any amount you feel is worth giving up to get the extra revenues. You put your price on the table with a condition. You might say it this way: "Normally I would charge $1000 for this job, but if you can shift it from Tuesday to another day, I can do it for $900. I am so jammed up on Tuesday that it's worth it to me discount my price to shift the work. In fact, if it can't be shifted from Tuesday, I'd better pass on it. I can't ask my other client to postpone. I don't want to inconvenience them. What do you say? What other day do you want me to shoot the job?"

You have just offered a conditional discount as an incentive, and you have reinforced your commitment to the welfare of your clients by not inconveniencing one with a change of shooting date. Buyers like discounts and they like suppliers who protect their interest. You have provided a practical advantage in a discount and a psychological advantage in shaping the client's positive impression of you.

Copyright Demands

Rule number one in negotiating is that you cannot negotiate the terms of something that you do not understand. Many photographers have a very difficult time when it comes to negotiating copyright rights with a client, because they have an inadequate knowledge of copyright. Consequently, they have great difficulty developing alternatives to the client's demands. It is not within the scope of this book to teach all that a photographer should know about copyright. There are two books on the subject, published by Allworth Press, the publisher of this book. You ought to read the *Legal Guide for the Visual Artist* and *The Copyright Guide*. You will become a better negotiator by reading them, because the knowledge they convey will add to your power assets.

There has been a long contest between photographers and clients over the ownership of rights. The clients have the economic clout to freeze the photographers out—they hold the purse strings. If you want some of the purse's contents, you have to either comply with their wishes or be uniquely desirable for the specific assignment. Most assignments do not require unique talent. A competitor of equal talent, who is willing to surrender more rights for the same fee as you offer, could be likely to get the job. One way to deal with such a situation is by taking a different approach from those of your competitors who concede the ownership of rights without negotiating.

You can differentiate yourself by dealing with the needs of the client rather than their wants. You do that by avoiding the use of the word "copyright" during a negotiation. Instead, determine how your clients will use the photographs. Once you have an understanding of the required usage, you can offer a proposal to license the rights to meet the usage needs. The word "rights" is a red flag in a negotiation. People fight over "rights" because it

is a psychologically charged word. Rights are hard to come by and are defended at any cost. But clients and photographers have no reason to fight over usage. We use things every day that we don't care about keeping forever. When you ask what rights the client wants, you are generally going to get an answer like "all rights." When you ask how the images will be used, you generally get a list of uses.

Rights and Market Segments

In the advertising market, the common demand from buyers is for the copyright or an exclusive grant of all rights. Advertisers usually want all rights to the images your shoot, in order to protect the perception of their products and services. In the corporate market, the buyers will most often want the copyright or an exclusive grant of all rights to those images that identify the company or its processes. These are usually called proprietary images. In the editorial market, the buyer usually wants limited rights. The exceptions would be prestigious magazines that want copyright or an exclusive grant of all rights only for photographs used on the cover of the magazine, since the cover is its flag in the trade—as precious as a logo is to the corporate buyer, and the product or service identity is to an advertiser.

All Rights and Buy Outs

Buyers of photography often use the words "all rights" and "buy out" to indicate that they want unrestricted use of the photograph(s) that they are commissioning. Buyers can also mean that they want the exclusive use in addition to unrestricted use. While the term "buy out" is not a legal term, the term "all rights" is an imprecise legal term—as in the phrase "all rights reserved" that often accompanies copyright notices on creative works. You should avoid the use of the term "buy out," because it is subject to

various interpretations in the trade. "All rights" means exactly all (each and every) rights that exist. Granted exclusively and without termination, "all rights" is the same thing as providing a copyright transfer.

If you limit the period of time that the client will own "all rights" or "all rights exclusively," you are retaining the copyright while giving the buyer the right to exercise all the copyright rights for a specified period of time. Granting a time-limited transfer of "all rights" is better than making a transfer of copyright, because it keeps ownership in your hands for the long run.

Countering All Rights Demands

Clients often ask for all rights or a buy out for very specific reasons. Understanding the reasons is helpful in trying to fashion usage alternatives to meet their needs. Let's look at a few of the reasons and your possible counterproposals.

- Corporate image and proprietary information are very valuable. Companies want to protect both. They do not want their product or service associated with anything negative. They do not want their personnel's images used in any way that might be even remotely unflattering to the individual or company. These things have happened to companies, and they want to guard against it. Having "all rights" is a way to protect their interests. You can offer the client "sole and exclusive usage rights," which means you will never allow any other party to use those assignment images.

- Liability is another concern. Clients that buy substantial amounts of photography are aware

that there can be lawsuits for lost or damaged original photographs. They do not want to defend a lawsuit for such a loss, especially when they paid to have the photographs produced in the first place. You can offer to hold them harmless for any loss or damage. If there is loss or damage, it is the client's money that is lost, because they paid for the production of the images.

- Clients prefer to make as much use as they want (not need), and "all rights" gives them that right. Again, we all want as much as we can get for our money. You can give them all rights for a limited period of time. It is the unusual image that is usable for more than a few years. Have a lower price for a time-limited exclusive than for a perpetual exclusive. That way you have given a discount for a decrease in what they are demanding from you.

- Clients often want to avoid negotiating any future usage because, once they are committed to a photograph, they cannot change easily or cost effectively. Their fear is that you will hold them up for an unrealistic fee for that future usage because you will have the power. You can offer to set the fees for any reuse as part of the deal that you are currently making. A percentage of the creation fee is usually appropriate. That eliminates future negotiations and settles matters while the power is balanced during the current, original negotiation.

Usage and Value

In its simplest form, usage can be divided into four basic categories: limited, unlimited, exclusive, and nonexclusive. The categories can be put into real-world terms easily by using the magazine market-place as an example.

Upper-tier magazines such as *Time*, *Newsweek*, and *BusinessWeek* require some exclusive categories of rights. For a cover, they insist upon exclusive rights for any purpose and for all time. That is "unlimited exclusive." For inside use, they insist upon exclusive use for a limited period of time, but they make additional payment for additional editorial uses after the period of exclusivity. That is an example of exclusive rights limited by time and specific use. These magazines generally pay three to four times the inside, full-page space rate for the cover. So the difference between all rights exclusivity and specific-use exclusivity for a limited period of time is a 300- to 400-percent increase. Using a similar approach, you can formulate a percentage increase for different levels of rights in advertising and corporate negotiations.

Lower-tier magazines will usually want nonexclusive rights limited to one use in one issue of the magazine. This limited, nonexclusive use will not command a high fee when compared to the cover of an upper-tier magazine. However, when a publisher wants to run your images on a nonexclusive basis but in several issues of one magazine, or in different magazines, the value increases.

To better understand how to establish relative values around the four categories—limited, unlimited, exclusive, and nonexclusive—you must understand the parameters of the terms. "Exclusive" means that the person to whom you grant the rights can use those rights, but no one else can. You can

assign all rights or any number of rights exclusively. For example, you could assign print media rights on an exclusive basis, so no one else can use the image in print media. "Limited" means that there are restrictions on the use. What restrictions might there be? Time, number of copies printed, and region are good examples. Obviously, the opposite terms, "non-exclusive" and "unlimited" have opposite parameters. Regardless of the parameters, the concept is that the more you buy the more it costs.

Fee Negotiations

Negotiating your fee is always the hardest task in a selling situation. The reason for that is because assignment photographers do not have, and have never had, an industry-wide pricing method as there is in stock photography. It is impossible to price creativity by formula, and your total price includes your production and overhead costs plus your creativity and usage fees. You can isolate the production costs and know your overhead, but how do you put a price tag on the creativity that you bring to any job? You can't—at least you can't do it before the job is done. After it is over, you know, or at least have a good feel for, the level of creative energy that went into the work, but can you really put a price tag on it? I don't think so, and neither can your prospect or client. But each of you knows that some jobs require more creativity than others. For example, a studio photograph of a teacup and saucer on plain white background requires craftsmanship, but how much creativity does it take? It takes some creativity, but not as much as shooting a snowmobile crashing through a snow mound in a winter mountain setting.

The fact is that much work that photographers do requires careful craftsmanship, but it doesn't tax the photographer creatively. While most photographers will try to be more creative than the client's job specifications call for, there is often little room to introduce highly creative thinking into an assignment, because either time or circumstances do not allow it. This means that you have to distinguish between what I call the "bread-and-butter" jobs and the "champagne" jobs. Most businesses run on bread-and-butter jobs, and they get a real boost in monetary and psychic income from the occasional champagne job. The first thing you have to distinguish before you offer or negotiate your fee is which kind of job are you being considered for. You will have more serious competition for the bread-and-butter job, and that means that you have to be more conservative in pricing it.

Fee Setting

Decide your fee on the basis of the level of experience, capability, and creative talent that the job really requires, and how much better you are than your competition when it comes to the kind of photograph you are being asked to make. If your price is questioned or challenged, use those factors to sell the fee. Remember TINSTAFFL!

You can point to other assignments of a similar nature—whether done for the same client or a different one—to demonstrate that you received a fee similar to the one you are quoting for the present job. Show tear sheets of the similar work that was similarly paid. It is your responsibility to justify your fee. Do it with facts and common sense. Quality includes completing the

job on time, within the estimated price, and in a creative manner. That is what you are pricing. Anyone can deliver a photograph that meets the prospect's basic needs, but you are going to deliver a photograph that meets the prospect's wants. This is more about selling than about negotiation. It is a good time to be a "broken record." Be direct and confident. Reassert that your fee is reasonable.

ASKING ABOUT THE FEE

If your client cannot accept your fee offer, then try asking a question like "Based upon your experience, what do you think the fee should be?" If the client's answer is close to yours, you can compromise. If it is not, you have a problem, and you have to ask the client if he really wants to work with you specifically. You cannot cut your fee by a substantial amount. If you do, you have told the client that you were just trying to exploit him with your first offer. The job cannot be worth $5,000 one minute when you present it and $4,000 the next minute. That is like saying that you padded the estimate by 25 percent. Do you want to work with people who pad their estimates to you?

No matter what people preach to you, there is no such thing as the right fee. If anyone knew the correct fee for photographic assignments, she would be indispensable, famous, and wealthy. Fee negotiation requires balancing interests: yours, your client's, and, in the case of an ad agency or design firm, their client's. Your fee has to reflect the value of the photograph to the client while preserving the value of what you bring to the job. Value is relative to the experience, creativity, capability, and reliability that you bring to the job, and it is relative to other costs the client will incur in the project. When a company is

doing a million-dollar media buy for ads, it is not looking for the cheapest photography around. That would diminish the return on the advertising investment. Keep that in mind. Tell clients that, if they want to maximize their client's investment, the best way they can do it is by maximizing the quality of the photography. And that means that you are the right person for the job, and that the right person costs more than the wrong person.

Always keep in mind when closing a sale that what you do has value. If it did not, the client would not be trying to buy it. You know the value of your services. The client might not agree with you. If you can develop a good rapport with your client, you might be able to get her to share her insights into the value of a job with you. That is not easily done, and it usually requires that you have some kind of ongoing relationship with the client. But your value increases as your rapport with the person does. When a person convincingly tells you that she wants you to do the work, but that the fee cannot be more than a given amount, you have achieved some level of rapport. You have convinced the client of your value and gotten the admission that she cannot afford your price. It is up to you to decide whether to meet her needs. Maybe you can do it with a reasonable rationale for lowering your price. Reasons like, I want to show you what I can do," or "Because you are such a good client," are acceptable reasons to lower a fee, but not to take a loss. Some differences of opinion cannot be resolved. Sometimes you have to say no. Remember, no one ever went out of business by saying no to a bad deal. Many people have gone out of business by saying yes to bad deals. Stay out of the latter group. Know your value and don't work for less, unless you are sure that it is a one-time step to achieving greater value in the future.

THE BOTTOM LINE

You must have a bottom line when it comes to fees. That bottom line should be based upon the costs of operating your business. Every day you work on assignments you have to earn a certain minimum fee just to stay in business. When a job doesn't measure up to that level, you ought to pass on it. If it does, you have a reason to take it.

OPTIONS PACKAGE

Over the years, I learned that almost any fee I placed on the table was going to be too high in the client's mind. If a client accepted my proposed fee without any discussion, I knew that I had priced the work too low. I hated that feeling. Fortunately, I managed to avoid that experience and find a way to focus fee negotiations quickly and usually in my favor. You and your client have positions on a fee and on rights. That sets up a negotiating range—with your position on fee at the top end of the range and her position at the bottom of the range, and vice versa when it comes to rights. When negotiating the rights and fee positions, you first agree on the rights and then on the appropriate fee for those rights. You normally end up somewhere in between the two starting positions.

I developed a way to set up a negotiating range that made my job easier. I combined the fee/rights package into one position, and then I proposed three alternative packages. Each package had its own specific set of rights and specific fee. In other words, I would offer a menu with three options. By doing that, I pushed the negotiation toward considering my negotiating range rather than the range set up by my clients and my positions. The three

options offered a range of rights and fees that went from my wants to my needs, and a range of rights that were similarly arranged.

An Options Example

Your client is asking for all rights exclusively and in perpetuity and has indicated a budget and willingness to pay $10,000 plus expenses. The images are for an annual report. Many of the images will be generic and will have value as stock photography. Some of the images will be proprietary, and you will have to protect them from use by anyone other than your client. It will take five days on location to shoot and another five days for travel and pre/post production. Ten days work for $10,000. That figures to be $1,000 per day. The rate you normally charge for this kind of job is $3,000 per day when you have to surrender all the rights. That means you want a $30,000 fee to fulfill the client's wants. Note we are talking about "wants," not needs.

You know that most annual report images will not be used for more than one year. There are some exceptions to this. For example, executive portraits might be re-used for the next year's annual report. They also will likely be used whenever the client needs an executive portrait to send out. You also know that some of the photographs are likely to end up in a corporate brochure within the next two years, because annual report photographs often make good filler material in brochures. That means that the client's *needs* are one year of use in the annual report, collateral use of the images for two years, and continuing use of the executive portraits.

The client's negotiating range is between the *wanted* all rights and the *needed* annual report and collateral rights plus liberal permission to use of the executive portraits.

Your usual fee for all rights is beyond the client's budget, and you are not inclined to accept half your normal rate for any all-rights deal. The executive portraits are proprietary. Companies don't want to lose control over their executive's portraits. Too many of them have shown up accompanying unflattering magazine articles, because the photographers licensed them for editorial use without care for the client's possible concerns. You can live without those types of sales, because you want to keep this client and get repeat business that could be worth a lot more than a few editorial stock fees.

Now you consider your negotiating range. You will grant all rights for $30,000 or annual report rights with protection of the client's proprietary interests for $10,000, your bottom line. You have a $20,000 spread. That is a very wide range. Now you make the strategic decision and set a goal to sell all rights exclusively to the client for a period of two years and to give a perpetual exclusive rights license for use of the proprietary images for a fee of $20,000. That package meets their needs and the most important wants, namely, to use the images in next year's annual report and in collateral uses for the usual two years.

When you present your offer to the client, you put all three packages on the table. In doing so, you have rejected her offer of $10,000 for all rights and priced it well above the budget, and you have created compromise for them with your bottom-line offer. You have avoided rejecting the client's offer out of hand by making your refusal more subtly through a higher fee for the all rights demand. At the same time, you have set up an all rights negotiating range between the client's offer and your proposed fee, in case all rights is the only acceptable license. More important, in between your proposed options is a compromise that fits the client's budget and meets her needs. From here on it is tactical bargaining. Your strategy has gone from

the planning to the operational stage. Now you must engage in a negotiation—remembering everything that you have learned about tactics in this book.

You have also avoided trying to close a $20,000 spread between your and your client's wants. That would be an almost impossible task. You have taken control of the direction of the discussion, and now you must make your middle option appear fair and reasonable to your client. And why shouldn't it be? It moves beyond meeting needs but does not reach for the dead end of trying to settle wants.

Rebuttals

Over time, as you gain experience negotiating, you will develop spontaneous rebuttals to some clients' routine claims. I have developed a few over the years. Here are some of them in script form.

Client: *I can hire a dozen other photographers to shoot the job for my price.*

You: *No doubt you can. I can get you a photographer who will shoot it for half of your price. But ask yourself this question: Why are they ready to do that? Could it be that they have a hard time getting work because they are not as good as pros who charge fees like mine? Maybe it is because they have no credible experience. Maybe it is because they don't really understand what has to go into a job like yours. Maybe you ought to check with some of their past clients before you hire them. If you check the contact list I gave you, I'll pay for the phone calls. They will tell you why*

I am worth the fees I charge. I think the important question is, do you want cheaper or better, not whether you can find a photographer who is cheaper. That's a given.

Client: *I can't move on my fee offer. Our client is holding us to the budget and there is no room for an increase.*

You: *Maybe you can cut back on something that won't make a difference. Cheaper photography could make a large and negative difference in the outcome. The photography is the centerpiece of the job. Look, if you reduced the cost of the card stock or size of the press run, you could save a bundle, the reader wouldn't know the difference, and there would not be so many brochures left over. Or you could reduce the size of the media buy by just a fraction of a percentage and it would have no practical effect. Or we could cut some expenses on the job by using one less model (or working on only one location, etc.). Or we could take a hard look at the usage. You want a big bundle of rights. I doubt that you need them all. You could save money that way.*

Client: *Give me a break on this job, and I'll take care of you on the next one.*

You: *I would consider that if I knew when and what the next one was going to be, and we set up the deal now, so I could get two purchase orders tomorrow.*

Client: *Why should I pay more for all rights? These photographs won't be used much except for the immediate use.*

You: *Then why do you need all rights? Save a buck. Buy only what you need.*

Client: *We set up a budget for the photography and your price exceeds it.*

You: I know it's hard to budget for a photography job without knowing all the details the photographer will consider when estimating it, but it seems that you miscalculated. You just can't expect that any photographer can meet your expectations when you have not estimated the costs high enough. If you estimated the price to buy a BMW to be $45,000, and the dealer said no possible sale of that model for less than $50,000, do you think the dealer would lower his price to meet your estimated shortfall? Your company wouldn't do that for its clients, and I cannot do it for mine.

A Sample Dialog

In my book *The Real Business of Photography*, I incorporated several dialogues between a buyer (Pat Buyer) and a photographer (Happy Shooter). I have incorporated one of them into this book because it shows how parties might speak to each other and how the photographer's strategy works in practice. The dialogue begins after Happy has offered his estimate with three options to the client.

Happy: Hello Pat. I wanted to check in to see if you have any questions about my estimate for the Slippery Snowmobile assignment. If you don't, I am ready to get started on the job.

Pat: I did look at it, and I have a few concerns that I do not have about the other two estimates I have for the job.

Happy: Let me resolve your concerns. What are they?

Pat: The option for different fees and rights are not what I expected. The other photographers just quoted the "buyout"

that I asked for. When I compared their prices to yours for that deal, your fee was the highest.

Happy: *I'm not surprised that I am the highest because my work is so well suited to your needs. I believe that is what got us together in the first place. I do my homework very carefully when I look for a client. I took the time to examine the fit between you and me before I even promoted myself to you. I was sure that you would see that I was particularly suited to do the Slippery Snowmobile work. It's that "particularly suited" that makes me cost a bit more than my competitors on this one. Getting those action shots you need out in the cold snow banks of Colorado requires skill and experience like mine. I don't know how the other bidders are on this job, but I'm certain that I can do this job better than they can, and now I have to convince you of that. . . .*

Pat: *(interrupting) The fact still remains that you are higher priced. How can I justify that to the account executive and the client?*

Happy: *Ask them if they have Ford mechanics tune up their BMWs. Just kidding. I wouldn't try to justify it. Instead, I'd suggest that you suggest that my option two presents your client with a near-perfect deal. They get all the rights they really need, and they don't pay for something they want but don't need. Look, they get three years of exclusive, unlimited use, and they don't pay for a lifetime of use that won't be needed because of model changes.*

Pat: *The continuing use is not the issue. The client does not want the images ever being used by another party. They have a fear that someday they will see one of their snowmobiles in a magazine story titled something like "Snowmobiles—Cripplers*

or Killers." They just want to be sure that something awful doesn't happen.

Happy: *Very understandable. I can solve that problem one of two ways. I can agree in writing to never license the photographs to anyone for any reason. I don't use advertising photos of products as stock photography. Or, I can give them the copyright transfer for the same price as option number two, if they agree to pay for any additional years of usage beyond three at the same yearly rate. How's that sound?*

Pat: *I think that they'll buy the transfer with a guarantee of additional payment for extended usage. But the price for your option two is still too high compared to the other photographers. So you have to come down.*

Happy: *I just effectively went from $50,000 to $30,000. I think $30,000 is a very fair price for guaranteeing that your images will never get into the wrong hands and three years of unlimited and exclusive usage.*

Pat: *Yes, but the client changes models every two years and that is the longest that they will pay for usage.*

Happy: *Well in that case, option one would have sufficed for their needs. It gives them the two years that they need with exclusive use.*

Pat: *Yes, but it doesn't give them the copyright.*

Happy: *I think I can solve our problem, but first I need to know what I am competing against. There is no point in my doing so, if I am simply going to be asked to drop my price at the end to match someone else's. I need to get a certain amount for a job like this because the job is worth it and I am worth it. I can't let my competition determine my value. What's your bottom line on the fee for the job? You must have one.*

Pat: *I've got a budget of $35,000 for the whole thing—fees, expenses, etc. I can't even think about asking for more because the account executive is not about to jeopardize our relationship with Slippery when we can get an acceptable result from a photographer within the budget.*

Happy: *For $35,000 I can give you everything your client needs with the protection they think that they need. I am asking you, if I can structure the deal in a way that does what I just said, will I get the job?*

At this point the negotiation can go in one of two directions. The buyer either acknowledges that he or she wants to work with Happy, or indicates no preference for Happy over the other bidders. Let's look at each scenario.

Scenario 1

Pat: *If you can meet my client's needs and eliminate the fear factor I spoke about for no more than $35,000 for everything, I can give you the job.*

Happy: *I can do it. I need a little time to come up with the right wording. Can I call you back in half an hour?*

Pat: *Sure. I'll wait for your call.*

Scenario 2

Pat: *Look Happy, you are a good photographer, but I have to go with the lowest qualified bidder to keep peace with the boss.*

Happy: *So where do I have to come in to get the job?*

Pat: *The low bid is $25,000 dollars for the whole deal with fees and expenses.*

Happy: I have to think about it, can I call you back in half an hour?

Pat: Sure.

Working the Scenarios

Now Happy has to get his mind in gear. He has the parameters for the "real" deal. The prospect's client wants maximum flexibility with exclusive use for the product model's life span of two years. In both scenarios, the budget constraint makes the upper price limit $35,000. In the second scenario, there is a second constraint from a competitor's bid. Dealing with the first situation is easier than the second because Happy has no real competition. The prospect has already offered him the job, if he keeps his price below the $35,000 limit. In the second situation, the prospect has introduced a new ally, Happy's competition. Now let's look at how to deal with each scenario separately.

Under Scenario 1, Happy has only to decide how to present his new offer to the prospect. His upper price limit is established. All he has to do is construct a reasonable proposal that meets the prospect's needs of all rights with exclusivity for two years. In the original estimate, the expenses totaled $12,971. This leaves $22,029 for the creative production fee without exceeding the $35,000 price cap. Happy comes up with this rational basis for the new price proposal he will offer: a transfer of copyright for two years, allowing unlimited use for the two-year duration of the transfer for a fee of $22,000. He will satisfy his need to get paid for more than two years of usage by an additional payment condition. This means his price will be $34,791, just under the $35,000 cap set by the client. Under Happy's original estimate, option number three was the closest to the new offer. It read: "Exclusive rights for one year

allowing unlimited use for a period of one year from the date of first publication for a fee of $15,000. One additional year of usage would increase the fee to $25,000." It would have brought the entire job to a price of $37,791. Happy is underselling his original position by $3,000. But he has a method to his madness, which he will carefully construct in writing so he can read it to his prospect and than employ the same language in his confirmation letter.

A New Option

Here's a copy of his new offer.

"Transfer of the full title to copyright in the images taken as part of the assignment. No rights can or will be transferred to any other party except that Happy Shooter may use copies of the images and the advertising in which they appear for the promotion of his business interests, in any picture books or photography exhibits, and as art for display purposes. If the images are used for publication of any kind after two years from the date of initial publication in advertisements, Happy Shooter will be paid an additional fee of $5,000 per year of actual usage."

This offer gives the advertiser all the exclusive protection and the rights it needs for the two years of the product model's life. It also gives Happy the right to do one important thing with the images and the ads themselves: He can use them to continue his niche marketing efforts. He can send copies of both to prospective clients in his routine niche marketing and promotion efforts. As soon as the advertising campaign hits the street, Happy will be sending a new promotion to the agencies and communications directors of other winter sports companies

and off-road vehicle manufacturers. This promotional right is potentially worth many thousands of dollars more than he traded off to get the assignment. Happy has surely learned one thing: The photographer has to be looking down the road all the time. You are the only person who can guarantee your own successful future.

CALLING BACK

The next step is a call to Pat Buyer to present the deal. Since it meets Pat's price needs, and really offers Pat's client all it needs, it should fly without a problem. If it doesn't, Happy will have to negotiate to finesse the deal to a conclusion. He will do that by continually reasserting that the deal meets the client's needs. If Pat tries to force a better deal, Happy will remind her of the commitment that a $35,000 buyout would fly, and that she indicated that her client would not use the photos beyond the two-year period before the model change. One thing Happy won't do is drop his rights position award, unless he gets the full amount of his original estimate. Happy has not lowered his price. He has obtained the value of his original price in a fee plus an award of valuable rights. If he lowered his price, Happy would be telling Pat that his price always comes down for the asking. In that case, Pat will be sure to ask over and over again. A good deal is one in which items of equal value are exchanged. The successful photographer gets the maximum value obtainable for his or her work in every deal made.

Under Scenario 2, Happy must deal with a bigger challenge. The prospect has introduced the competition as a factor. The competition might or might not be real. It is not uncommon to cite competition to a photographer in an effort to keep the price

of work down. Sometimes there is real competition in play, and other times there is not—it's just a tactic. The problem is that you never know which situation you are facing. The way to deal with the problem is to ignore it. You cannot solve the problem. You will never know for sure. Why should it matter? You submitted your proposal based upon your policies and pricing criteria. These are the underpinnings of your business. If you are ready to meet the competition's deal just as the competition proposed it, then your competitor is running your business. I assure you that your competitor will not run your business as well as you will.

This kind of situation calls for confidence on Happy's part. He has it because he understands several things about the business process. The prospect asked him for an estimate like every other bidder contacted. But the prospect pursued Happy's bid even though it was much higher than the competitive bid later quoted by the prospect. Why would a prospect pursue a $30,000 estimate when he claims to have a $25,000 estimate that provides everything he needs? The answer is simple. The prospect wants to work with Happy. If not, the prospect would have just said "Thank you, but we are giving the job to a photographer who has a much better price."

Armed with the positive belief and outlook that Pat Buyer wants to work with him on the Slippery Snowmobiles assignment, Happy plans his response to deal with Pat's attempt to get his price down. He constructs a statement of his reasons so he can be prepared to recite his position when he calls Pat back. That call might go like this:

Happy: *I've thought about the competitive offer to do the job for $25,000, and I am sorry that I cannot even consider meeting it. I thought that would be the case when we were*

talking, but I wanted a chance to go back over my figures in case I had made a mistake. I didn't. My quoted prices are as competitive as I can be, and I know them to be in line with those of the other successful photographers in town. Maybe my competitor can do it for $25,000, but all that says to me is that he doesn't command proper professional fees or he is desperate. In either case, I think I don't want to be in his situation, so I have to stay with my price. But I did work out what I think is a fair deal, which will allow you to save your client a few dollars while getting the best work available.

Pat: *What's your best deal?*

Happy: *For a $35,000 maximum including fee and expenses I will transfer the full title to copyright in the images. No rights can or will be transferred to any other party except that I may use copies of the images and the advertising in which they appear for the promotion of my business interests, in any picture books or photography exhibits, and as art for display purposes. If the images are used for publication of any kind after two years from the date of initial publication in advertisements, I am to be paid an additional fee of $5,000 per year. If there is any good collateral material to be produced to support the ads, I could cut back the fee a little bit more if I can get either a credit line for the photography and/or enough copies so I can use them to promote my business. That would be worth a couple of thousand dollars to me. On that basis, I could knock the price down to $33,000.*

Pat: *You are still $8,000 higher than your competition.*

Happy: *Yes, I am, and I am going to stay $8,000 higher because that is a fair price from a professional that has proven to you before he ever met you that he can deliver the work you need,*

when you need it, at a fair price. I don't know who my competitor is in this case, but I hope you do. You are talking about a competing photographer who seems to me to be too inexpensive for the kind of work involved. I am a frugal fellow, and I keep my operating expenses as low as I can without sacrificing quality of service. If I were charging this competitor's rates, I'd have to cut back in ways that would affect the outcome of the work. I can't do that and call myself a professional. I think you want to use me, or you wouldn't have asked me to estimate the job. Give me a shot at this. I'll try to make it up to you in the future with great value and service. Do I have the job?

At this point Happy had dropped his price based upon replacing one kind of value with another. The client's cash price went down and Happy's compensation will now include partial payment by virtue of a credit line and copies of the finished work product for his promotional use. These two items have a cash equivalent value to Happy. Pat is either going to give Happy the job or stonewall. If she stonewalls Happy, the next move for Happy is to push the matter to a conclusion. In that case, it becomes Pat's turn to make the hard decisions. Happy has already staked out his final offer of $33,000. He cannot and will not meet the competitions price in any event. If he did, it would be like telling Pat that his original offer was an attempt to get an extra $8,000 for the work. That is not going to make Pat favorably inclined to use Happy in the future. Pat wants a professional photographer, not a huckster to service her needs. Happy has also turned a favorite buyer's ploy around on Pat. Buyers often ask photographers to cut the price on a current job with the prospect of being better treated on a future job. Happy played that classic move in reverse by offering greater value and service

in the future. That greater value and service could be achieved by putting in extra hours on a future job or two without extra charge. It doesn't have to be by cutting a normal fee.

Let's assume that Pat is going to have one more go at Happy. Here's the dialogue.

Pat: *Happy, your offer is better, but how can I justify spending $8,000 more to use you on this job?*

Happy: *I'd suggest that you explain the reality. Let's face it. If you wanted the $25,000 guy, you wouldn't be talking to me right now. In fact, we might not have ever gotten past the first few minutes of our previous conversation. You know he isn't your first choice, and I know that. Why? Might I speculate it is because you think I will do better work? Your client is going to spend several million dollars on advertising and collateral using the photographs that you commission today. How can anyone risk having less-than-excellent images in a multi-million dollar ad campaign when $8,000 will assure success? If that isn't true, then I can give you the name of my assistant. He is trying to get started in the business. He'd probably do the job for $20,000, so you could save $13,000 over my estimate. I know you don't want to take that risk. Why take any risk? You have a $35,000 client-approved budget. My work comes with the assurance that the job will get done the way you and your client need it. Pat, I think you have to decide if you want to ride in a Ford or a BMW. Can I start planning the job?*

Pat is now up against the wall she put you against. It is now her decision. You have given her food for thought. She decides and you live with the decision. She decides in Happy's favor.

THE FINALE

The negotiation will end in one of two ways: Either you reach agreement or you fail to do so. When you have reached an agreement, you should look over the notes you have been making throughout the process and summarize the items agreed upon. You have been keeping notes, haven't you? All good negotiators keep notes so that they can write up an agreement or complete a form agreement that embodies that which was agreed upon by the parties. After you confirm the details in the concluding review with the client, you will write up a confirmation and send or deliver it to her. The last thing that you want is for anyone's short memory to cause a subsequent disagreement over the terms that you originally agreed to. Confirming the agreed-upon deal is the final act of the negotiation and a critical one. Be sure not to skip that important action.

If you failed to reach an agreement, express how sorry you are that things did not work out, and confirm that you hope to be given another opportunity to work for the client on a future assignment. Then send her a letter saying the same thing so that she sees you mean it, and that you really are ready to come back and try again. Some people take failed negotiations to mean that the other party wants no part of them in the future. You should firmly dispel that thought if you want to build your clientele and bank account.

BE THOROUGH

There are no shortcuts in negotiating. You have to consider intangible fears like performance issues and value issues like time, copyright/usage, and fees. You will have to understand the value relationship between fees and usage. You will have to understand

your client's positions and separate the wants from the needs, so you can develop a range of alternatives to build a compromise around. Never skip confirming your agreements unless you like to negotiate disputes (and, if you do, maybe you ought to try law school). Always keep the door open when negotiations fail. Tomorrow might bring a better job with a better budget or relaxed demands. That is the one you have been looking for, so don't miss the opportunity to get a shot at it. Thoroughness is a key component of negotiating—before the fact when doing homework, during the discussions, and after the fact when wrapping up.

Chapter Seven

Negotiating Stock Photography Fees

There is only one thing to negotiate when you are licensing stock photographs—that is, the price of the license. There are no expenses or possibilities of a time shift. There is no risk about what the photographs will look like. There are no expenses to negotiate an advance for. Transfers of copyright ownership are not an issue. There is a pricing system in place for various types of uses. You don't have to do much homework or preparation. Sounds like a dream world, doesn't it? But, in fact, it can be more of a nightmare than a dream. Since the only major factor is price, the competition over sales can be ruthless. As competition holds prices down, many stock photography sellers frequently accept low prices, because the cost in time to them for negotiating a few dollars more in revenues is not worth it. In spite of the intense competition, there is still an opportunity to negotiate, especially when licensing rights for high-priced uses such as advertising.

Abstract Factors

When you are negotiating a stock sale, you should try to acquire and consider certain pertinent information at the beginning of the conversation. This information is used to help you sell the client on your image and price. Let's look at each one of the items.

Type of Client

Who is the buyer? Does the name give you any indication of how deep the buyer's pockets might be or how reliable they might be for payment? You might recognize the name as an upscale agency that works with prestige accounts, or as a local business with a bad credit reputation. If the buyer is an ad agency or design firm, try to find out who the end user is. If you recognize it as a company that goes first class in the quality of its advertising and promotion and you know that your image stands out, you can probably get a good price for whatever rights they want.

Competitive Images

You must evaluate the extent of the possible competition you will face in making the sale. The level of originality in a stock photograph is directly related to the level of competition it faces and its value in the marketplace. What is the nature of the specific image the buyer wants to license? Is it a unique photograph, meaning that there is little chance the buyer is unlikely to find a similar image among your competitors? Can dozens, hundreds, or even thousands of similar images be found in stock agencies around the world? Can similar images be found in royalty-free collections? If so, you know that you are trading at the lowest

end of the price scale. If you are familiar with stock catalogs in print or online, you will have a good idea how your specific image stacks up in the world of stock photographs. If there are no, or only a few, similar images in catalogs, you are in a great position.

Timing

When is the client's deadline? Just as in assignment work, a tight deadline is to your advantage. The buyer called you because you have an image that meets a need, but it also must be wanted right now. Remember, the buyer knows exactly what the image looks like. Coupled with a tight deadline, you can use those temporary assets as an insurance policy. The message to the buyer is: Buy now at the offered price and eliminate the risk of not getting the image in time.

Motivation

Why does the buyer want this specific image? This is not about the buyer's need to use it. This is about the image's properties that make the buyer want it. He must like it or he wouldn't price it. Why does he like it? The answer to the question tells you what features to recall when selling your deal to the buyer. In the sales world, there is an old adage: "Sell the sizzle, not the steak." You know why chain restaurants put photographs of their dishes in the menu? They do it for sensory appeal. Once you know what excited the buyer about the specific image, you can casually mention it as your discussion progresses. If you cannot find out why he likes it, then look at it to see what distinguishes it for the type of use the buyer wants to make of it. Then sell that feature.

CONCRETE FACTORS

The next pieces of information that you will seek relates to the concrete factors that affect the price of a stock photography license. These five factors help you determine the potential value of a license, based upon the traditional rules that govern the pricing of stock. That rule is: The more visible the image will be in use, the more it should cost to license it. Let's look at each of these factors.

- The size of the reproduced image, such as full, half, or quarter page or screen, indicates the relative importance of the image to the project. Bigger means it is more important. Consequently, it should cost more.

- The placement of the image is an important factor. A cover photograph costs more than one used for inside use. A home page on a Web site costs more than a secondary page.

- The geographic and language distribution of the intended use also has a bearing on the price. Worldwide rights cost more than North American rights. The right to publish in four languages is more expensive than the right to publish in English only. Language is related to audience, and more languages means bigger audiences. This means a higher price. Don't forget that any use on the World Wide Web is a worldwide use. Even if it just for a Web site in one country and published in one language, it is automatically a worldwide use.

- The type of media is also important. Print media prices are usually based upon circulation or press run. Electronic uses are usually based on either quantity or duration of use, but sometimes on both.

- The market segment served is also important. Advertising applications command higher fees than corporate uses, which command higher prices than editorial uses.

- Circulation and press run (number of copies printed) are ways to gauge visibility: The greater the numbers, the greater the price.

Buyers are used to being asked for this kind of information, because they experience it every time they try to license stock photography. It is the standard way prices are set. If you access an online stock agency and look at pricing, you will find that the above factors are used to automatically calculate prices. Photographers have several options if they want to purchase stock photography pricing software. Each available software product builds prices on the above factors. Unlike assignment photography, the pricing of stock photography is very systematized. However, systems do not always assure that you will get the best value for your image. Systems operate on rules, and rules can limit some opportunities.

EXCEPTIONS TO THE RULE

There are times when stock pricing systems fall short of the mark. You will have to be observant and contemplative to find them, so you don't sell your stock at bargain prices or at prices that are

unrealistic for the buyer. Two different stock usage scenarios are described below. As you read them, you will see that (according to the rules) one photograph is clearly worth more than the other. After you read subsequent paragraphs, you will understand how the system can lead you astray.

Scenario One

The buyer represents an international credit card company. The company wants to license an image of a typical business-man checking in at a hotel registration desk. The image will be used on the front panel of a tri-folded 8.5" × 11" brochure con-taining a credit card application. The image will cover most of the front panel. The press run will be five million copies to be distributed worldwide in five languages. Considering the stock pricing factors, this sale should warrant high price. You quote a price of $5,000.

Scenario Two

A manufacturer of a particular type of valve used in sub-marines to control the sub's dive rate and angle calls you. You have photographed that part of a submarine's control panel for the Navy, and since it is an unusual shot, you placed it on your Web site. In this case, the picture is going to be used in a five-color, slick 8" × 8" brochure, at a full page on the cover. Then you learn that the press run will be only 100 copies, because there are only a half dozen companies worldwide that manufac-ture submarines—few navies have them or can afford them. They are printing 100 copies because they want a two-year supply that will be sent to all the higher up engineers and designers in the six companies. With such a small press run, the

use appears to be miniscule compared to the credit card sale. You quote a price of $500—double the price recommended in pricing software—because you have one of the few pictures of that valve in a submarine, so you know you have little competition.

The Surprise

The credit card company buyer refuses your price and licenses from another very savvy photographer for $2,000. The valve company takes your offer without hesitation, making you feel like they perceive they got a bargain. What happened?

You did not consider the real value of the images to the buyers. The credit card company was creating a throw-away pamphlet, used in counter displays. People pick them up and throw them away a day later, or use them to write phone messages on. Maybe one percent of them get sent in as applications for a card. The application is not worth a lot of money. It never convinces anyone to apply for a card. It is just distributed to make it *easy* to apply, if something else makes you *decide* to apply. Why would the company spend a lot of money for that kind of end use? There is no good reason to do it.

On the other hand, the valve company's brochure is the only way it can show its product to the engineers and designers. The valve is a critical piece of hardware because, if it malfunctions, the sub might dive below its crush depth. Your photo is proof of the fact that the U.S. Navy uses it, and that visual endorsement is as good as a written one. Your picture is a main element in the company's sales effort. Without it, the valve company might not convince anyone to buy its product over another manufacturer's. On top of that, you forgot to research how much each valve costs. If you

had, you would have realized that anyone selling a single valve with a price tag of $210,000 must have a very unique and important product.

If you had priced the credit card sale at $2000 and the valve sale at $5000, you would have made both sales. There are exceptions to every rule. You just have to look hard for them, and doing so can put extra money in your bank account.

FIND THE EXCEPTIONS

Most stock sales are routine, but as the example above indicates, some can be exceptional when the pricing doesn't conform to the traditional rationale of stock photography pricing. You have to be on the lookout for these exceptions to the rule. When considering pricing stock, you should take time to ask questions about the end user and use. Then you should reflect on the answers. If you have time or can postpone giving an immediate price, take time to look the end user up on the Internet. Get a feel for what they do and how big the company is. Try to get a fix on the size and nature of the customer base for the specific product line the stock photograph will be used to promote. There is a positive correlation between the size of a company and the size and nature of its customer base. There is no hard-and-fast rule for determining the pricing levels for the differences in the relationship between size of company and size of customer base. However, when you reflect on the information, you might see a level of dependency on successful promotion of a single service or product. Just as in the example of the valve manufacturer, some small companies will pay dearly for the right image

because part of their future is riding on the success of the promotion containing that image.

"ENSURANCE" FACTOR

You know that risk is a factor in business and in negotiating. You know that one hidden concern of an assignment-photography buyer is that the commissioned images will not meet expectations. Stock photography totally eliminates that fear. The buyer can see the exact image he wants and will likely end up using. The risk is gone. Your competency is not a factor, and expressing your commitment to delivering high quality is not a useful tactic. But there is a new factor you can use to your advantage. I call it the "ensurance" factor. By preproducing an image the client wants, you have eliminated risk and ensured the desired result. "Ensure" and "insure" are synonymous, but they do have different connotations. We know insurance is normally acquired by paying a premium. "Ensurance," on the other hand, is normally free. My point is that when you have ensured the buyer, you cannot charge a stand-alone premium, but you should get a premium price.

How much should that premium be? I don't know. No one knows. You have to find it by probing the client's willingness to pay. The trial balloon is a good tactic to use in probing the payment point. Ask the buyer: "What would you say if told you that the price for this image at your level of usage world be $X?" If you get an OK, then you were too low. If you get a "Too high" you then ask: "What do you think is a fair price, considering the fact that this image is exactly what you want and you don't have to look any further?" When you get their price wish, you have a negotiating range.

SELL THE IMAGE

When you are negotiating a stock price, take the time to look at the image. Ask the buyer what attracted him to it for the intended use. Listen carefully to the answer. Are there aspects of the image that make it uniquely suitable for his use? Are those aspects likely to be found in competitive images? Ask whether he has located other images that he is considering licensing. If he says no, you are ahead in the game: He is calling you because he has not yet found what he wants.

Make him want your image. Talk about how well it fits his intended application. A bit of selling always helps when it comes to getting the best value for your product. Ask if he is looking at the image. If he is, point out one or two special points about the image. If he is not, suggest he look at those special points now or when he next has the image in front of him. Help him understand just how special your image is.

Not every photograph has special appeal; but if it does, learn to look for the signals from the buyer about how much it appeals and why. I know from decades of experience that when you have the photograph that the buyer *wants*, you can get a much higher fee for its use than when it only meets his *needs*. Wants cost more than needs: Price accordingly.

I once had a magazine publisher divert a cover shot for an existing magazine to become the cover of the premier edition of a new magazine. Within the selection I sent was an image of a teenage girl sitting on a corral fence gently stroking the face of a red-bridled gray horse. When the art director called, he told me that while the particular image was good for the application that he had requested the images for, but it was "perfect" for the cover of the premier issue of a magazine for teenagers about

horses that the company was going to launch soon. Needless to say, I wanted more money for the premier use. The client understood this, but he balked at the level of increase I asked for. The picture was of a teenage girl sitting on a fence and stroking the face of a red-bridled gray horse. The girl's face was very expressive. I kept pointing out how the girl's face was "alive with love for the horse" (actual words used). The editor had to clear my higher price with his boss. I overheard him saying: "I know it's more than we want to pay, but this is the one image out of all the possibilities in which the girl has a real loving look on her face." I ended up getting my price.

PRICE LEVELS

Stock photography is usually licensed on a nonexclusive, limited-use basis. Occasionally, buyers need some kind of exclusivity, such as media (print) or geographic area (North America). Sometimes they need total exclusivity—that is, they don't want this image to appear anywhere else after they license it for a specified period of time. You have to be prepared for such demands by having a pricing schedule for nonexclusive use, with multipliers for different levels of exclusivity and for duration of use.

There are no hard-and-fast rules for developing the factors for increasing price according to level of exclusivity and duration of use. I refer you back to the example in the previous chapter where you read about levels of exclusivity in periodicals and how they affect fees. It can serve as a starting point for your own calculations. You can also learn what percentage increase other photographers are using by participating in Internet bulletin

boards for stock photographers. Photographers may or may not share their actual prices, but they will usually share the factors that they use to calculate values above their base prices.

Horse Trading

The dictionary defines horse trading as "shrewd bargaining and reciprocal concessions." Negotiating assignments has more opportunities to horse trade than negotiating stock prices. Usually the stock buyer is not seeking more rights than he needs, so it is difficult to present different usage/price packages. Time shifting is not an option. There are no expenses to play with. The only item that is on the table is the price. That gives rise to this question. What tactics can be brought to bear in negotiating a stock price?

Some that may fit are Broken Record, Bold Response, Trial Balloon, and Candor, because these tactics can be helpful when negotiating a price. You should review those tactics in terms of the stock-selling situation (see chapter 5). I am sure you will see how they can work for you in some situations. But there are two tactics that can have particular value in negotiating stock sales. Trade-Offs and Nibbling have a special place in the life of the stock photography sale.

Applying the Trade-Off

There are two potential values that can replace cash in a stock sale. One is a credit line that could lead to more sales. By that I mean a credit line that lets people find you if they want to see your work or inquire about your photographic inventory. A credit line that

reads "Photo: Pat Photographer" is not what I mean. You want a credit line that reads "Photo: *www.patphotographer.com.*" The latter tells viewers where to find you. That can lead to more sales than simply getting your name in print. The other value is copies of the piece in which your photograph will appear, if it is to appear prominently, and especially if it is credited to you (even with just your name and not your Web site). Good products containing your photography make good promotional tools for stock photographers, just as they do for assignment photographers. In the ideal scenario, you get both the locator credit line *and* copies of the brochure. This tactic has the advantage of allowing you to present options, which is a tactic in itself.

Nibbling for More

You will recall that Nibbling is going for some added benefit after the deal is done. Here is an example of Nibbling with a Trade-Off.

You have just made a deal with a buyer for the use of a stock image for one thirteen-week advertising cycle. You think that it is likely that the buyer will want additional cycles of use, but he is not asking for it now because he is unsure and does not want to commit to the additional fee until the company assesses the success of the first cycle. You know that because you tried to sell him extended use during the sales process (you did, didn't you?), and he refused it because of the risk.

Once you have agreed on the basic deal with one cycle of use, you get a bright idea about saving him money—if he decides on the second cycle. You also use the power of competition to motivate him. Here's a sample pitch: "Listen, I just had

a thought that could not only save you some money, but it also has an element of insurance for you. If you want that second cycle and come back to me later, I am going to charge you the same amount we just agreed upon. Unlike some folks, I won't inflate the price, because we agreed on it. (That has to make them think.) The only thing that could prevent me from relicensing to you is if someone comes to me and asks for, and is willing to pay for, exclusive rights to use the image. I can't refuse a sure sale for a maybe. I have a proposition for you. If you pay an additional 20 percent, I will guarantee you that I will not license any rights that will interfere with your use of the image for a second cycle, and for an additional 20 percent I will guarantee to license the second cycle with a 30-percent discount off the price we just agreed to. You will get the insurance you need to have the image available, and the 40 percent more you pay now will be partially offset by the 30 percent discount for the next cycle. So your effective cost will only be 10 percent higher for the guarantee and usage. Do you want both options?"

So you can see how a good negotiator is always thinking. In the above scenario, you have chosen to try to put more money in your pocket now rather than wait to see if you can earn it later. It is up to you whether a dollar in the pocket right now is worth more than a greater amount that might come later. Personally, in the situation I just described, I'd take the money when I could get it.

STAY FOCUSED

When selling stock, you have to determine what factors could influence the value of your image and whether any exceptions make those factors a price booster or buster. Remember, you are

the buyer's risk. Like insurance, "ensurance" has a premium attached to it. You get that premium by reinforcing in the buyer's mind why he wants your image. Only then are you ready to spar over the price level. When you do, you can employ the tactics that fit and also use those that might bring benefit after you close the deal. Stay focused on one thing: Stock licensing means fee negotiation alone. Keep your eye on the price and also on the factors, exceptions, and tactics that can help you get the right price.

Chapter Eight

Negotiating

Contracts

You can't be in business without sooner or later being handed a contract to sign. It might be a contract to purchase goods or services or, even more likely, to provide them. Regardless of which, there is never any reason to assume that a contract is ready to be signed the second it is presented for your signature. In spite of that fact, many business people are all too ready to sign on the bottom line without critically examining the contract, discussing its terms, and negotiating those terms to arrive at a more acceptable agreement. There seems to be an instinctive belief that a contract is a take-it-or-leave-it offer, and no negotiation is possible. The simple fact is that there are few contracts written that are not negotiable. The few that do exist are usually products of a negotiation that preceded the drafting of the contract. So let's learn how to negotiate a contract, so that you have a say in the agreement.

REQUIRED EXPERTISE

Developing expertise in contract negotiating takes four things. First, you have to know what a contract is and is not. Expertise means specific knowledge, and you get that by studying. Second, you have to have an understanding of language. You do not have to have the word skills of a writer, let alone a lawyer, but you do have to have a reasonable grasp of contract language. If you don't have that, then get help before you try to negotiate. Third, you have to know the tactical means of negotiating. By that, I mean how to explain why your counterpart's demands are unacceptable and how to offer alternatives that are acceptable. If all you do is reject without offering alternatives, you are simply refusing and not negotiating. Fourth, you have to learn to keep the process in perspective. Contracts are not enforceable until the parties sign them. There is no liability in negotiating. There may be some if you do not.

WHAT IS A CONTRACT?

From a business perspective, a contract is a mutual understanding. Legally, a contract is an enforceable agreement. "Enforceable" is the keyword. We can enter into many agreements in life, but most of them are not enforceable.

Here's an example: A client asks you to do some work for him. His budget is low, and your price is high. He asks you for a price reduction on the work, and he says that he will make it up to you on the next job you do for him. You agree and give him the discounted price that he is looking for. A few weeks go by and he calls you with the next job he has. Does he have to provide you with that extra payment he promised? No, he does not, because the agreement that you made with him is not an enforceable

agreement. In short, it is not a contract. All your client did was to promise you a better deal. You accepted the promise. Both of you agreed, but you did not form a contract. He made you an offer, and you accepted it, but the deal lacked one critical component: consideration. "Consideration" is something of value that the parties exchange to support the offer and acceptance made in the course of the deal. Both of you agreed, but you did not form a contract. A contract must have three things: offer, acceptance, and consideration. When all three are present there is an enforceable agreement—a contract on the table.

CONTRACT TYPES

Contracts can be either written or spoken. Spoken contracts are sometimes referred to as "verbal" or "oral." Let's call the spoken contract "oral," since all contracts consist of words (the meaning of "verbal"). While the principles of negotiating are applied to both written and oral contracts, if you are going to go to the trouble of negotiating a contract, you ought to have it written down when you are done. Poor recollection of oral contract terms have probably led to more avoidable business disputes than any other cause. Avoid oral agreements in business. They are generally worthless in any subsequent dispute. That is why your client often presents you with a contract to sign when offering you work.

INITIAL STEPS

Negotiating a contract requires three important initial steps. Skipping any one of these is almost a guarantee of failure. When you receive a contract, it is wise to make at least one photocopy

of it. This is an editing copy. It allows you to mark up the contract with notes, cross-outs, and additions without making the original unusable. Once that is done, you are ready to take the first three steps.

Read It

Step one is reading the proposed contract. I say "proposed" because it is not a contract until you agree to it. You are reading an offer from your client. Keep that mind-set. It is an offer, not a decree. As you read the document, make pencil notes on your photocopy. A few key words to jog your memory on what came to mind as you read each section will usually do. You can use a yellow highlighter to mark the parts that you know you will want to negotiate—usually, those deal with fees, rights, and liability. Underline in red any word that you do not understand. There are many words in the dictionary; if the person who drafted the contract used words that you do not understand, you cannot have a "mutual understanding" until you understand those words; keep a dictionary at hand. Look up any word for which you do not have clear understanding of the meaning. Misinterpretation of the meaning of a word can often lead to future problems, and sometimes those problems end up in the courtroom at great expense to the parties.

One example of how a definition can mean so much can be demonstrated by the word "advertising." A photographer signed a contract granting "advertising rights" to a client. The client placed ads in magazines and printed brochures to sell its product. The photographer protested the brochure use, claiming it to be promotional, not advertising, use. The case went to court. The photographer lost the case. The judge relied on the dictionary definition of the word "advertising," which is "the act of calling something to the public's attention." The judge

said that the magazine ads and the brochures fit the definition perfectly. The judge rejected the photographer's argument that photographers had a different understanding of the word. He said people rely on dictionaries for meanings and not on photographers' interpretations. The lesson learned is to keep a dictionary nearby. A broadly defined word is exactly that. If you don't want to accept broad interpretations, then don't accept broadly defined words. Specifics are better than generalities in contracts.

Understand the Content

Once you have edited the contract, you are ready to move onto step two. First, write down any words that are underlined in red. Then, write the dictionary definition of the word next to it. You will refer to this list later on. Review your editing copy and make a list of each problematic clause in the same order as these clauses appear in the contract. These should be highlighted in yellow and easy to find. Then think about possible alternatives to the clauses that you have listed. Maybe it means adding some words or deleting others. You might have to rewrite an entire clause. In the end, you should have a clause that you want to substitute in place of the one offered. These newly constructed clauses will be your counteroffer. Make sure that you have those new clauses spelled out exactly, word for word. You do not want to be formulating your position in your head in the middle of the negotiation (unless you must).

Now make some notes about why you can't accept the clause or clauses as offered. A good negotiator has a reason for rejecting any word, clause, or contract, and at the same time has an alternative to offer. As a final process in this step, you should also write down the minimum you will accept—that is, the bottom line for each of the clauses in dispute. If you have no bottom line,

there was no reason to begin the negotiation. Having no bottom line means that, eventually, you will probably accept the offer as made to you in the first place.

Reach Agreement

So far, you have evaluated the offering and come up with a counteroffer. Now it is time to move on to step three, reaching agreement. It is time to talk to your counterpart. Simple negotiations can often be handled with a brief phone call. Complex ones often require an exchange of written drafts, along with phone calls to discuss the reasoning behind positions. Note that I said "reasoning." Negotiation is more about reasons that make sense than it is about power. You should never do something that does not make sense to you. Nor should your counterpart. A meeting of the minds results in a mutual understanding only when the parties are reasonable. You cannot negotiate with an unreasonable party, and there are such people and companies. The most difficult negotiations are best handled face to face when the situation permits, because most people want to be "seen" as reasonable.

EASIER TO HARDER

Resolve the least-disputed clauses first. This sets a tone for future agreement, and the word "yes" is easier to get if it is part of a pattern of yeses. Prove that the two of you can agree on the easy ones, so it will be easier to reach agreement on the difficult ones. The added benefit of working from easier to harder issues is that, once both sides have committed time and energy to resolving some of the issues, it is harder for both to give up on a tough issue, because of that time and energy investment.

Compromises on the difficult issues are simply more acceptable when you have already made good progress to that point.

TACTICAL CONSIDERATIONS

The tactics used in negotiating contracts are no different than those used to negotiate an assignment or a stock photography sale. The Trial Balloon and the Trade-Off are probably two of the most used tactics in contract negotiations. You offer alternatives on a hypothetical basis, and you give in on one clause or part thereof to get the other side to give in on another. Every tactic you read about earlier in this book applies when negotiating a contract.

EXPERTISE

When you are dealing with a contract, don't make the mistakes of either thinking that you have legal expertise or that all legal expertise on the other side is correct. Lawyers make mistakes just as photographers do. When you are confronted with a legal concern in a contract, like a liability or hold-harmless clause, you should have someone with proven expertise check the clause. What's the difference between negligence, gross negligence, and willful negligence? I am not asking what you think about what the words mean: I am asking how the legal system decides which exists. A lawyer—not you or I—should answer that question.

Here's another example: Most contracts have an indemnification or hold-harmless clause. When you are indemnified—that is, when the other side will pay any losses you incur from any claim made against you—will the indemnifier pay for your defense

if you are sued, or just pay the judgment against you? It will pay for your defense, if you add the words "and provide a defense for" immediately after the word "indemnify." Once again, a lawyer will pick up such things in a contract's legal provisions.

Contracts can have business issues and/or legal issues. Legal issues are best either handled by a lawyer or, if by handled you, with a lawyer's counsel. It is easier for a lawyer to make good photographs than it is for a photographer to practice law capably. A little money spent on a lawyer as preventive medicine can eliminate the huge expense of hiring a lawyer to fight the lawsuit that arises because you either didn't understand the contract or didn't understand your legal obligations under the contract you signed.

A good friend of mine has been a lawyer for decades. He describes some lawyers as "deal breakers." He means that once they are called in, they make it a point to find so many things wrong with a deal waiting to be finalized that the contract falls apart. Please do not take this to be a condemnation of lawyers. I think lawyers are indispensable when it comes to protecting a business. I don't think that they are indispensable when it comes to running a business. Businesspersons run businesses. Lawyers practice law. When you need legal advice on a contract's legalities get it, but make your own decisions about the business aspects.

WRAPPING UP

You can now see that, with the exception the legal aspects of contracts, the process of negotiating a contract goes through the same stages and uses the same tactics as any other negotiation. Your homework is reading and understanding the contract, coupled with evaluating the issues and constructing alternatives to things

you have problems with. Discussions employ traditional tactics, and eventually you end up with an agreement—or, you don't agree and there will be no contract. Some elements of the contract might require consulting a lawyer, whom you ought to select for his legal expertise, not because he has opinions about how you should run your business.

The wrap-up to negotiating a contract is signing it, the simplest act in the process.

Chapter Nine

Negotiating

Purchases

If you can negotiate from the seller's side, you can easily adapt to negotiating from the buyer's side. Even though you might not have evidence of it from the behavior of the buyers you have dealt with, the principles, psychology, and tactics are the same. A good buyer does homework, develops a plan, and then engages a seller in a negotiation. This chapter will focus on techniques that you can use to gain some advantage in negotiating your purchases.

Negotiating Opportunities

It takes at least two willing parties to have a negotiation, so that is the first criterion for a recognizing a negotiating opportunity. Not everything you purchase is open for negotiation. Your groceries, insurance, electric service fees, and many other daily necessities are locked into established price lists that great

numbers of consumers are subject to. Generally, you will find a negotiating opportunity when you are buying items that you do not buy frequently or that you buy in volume when there is enough margin between seller's cost and offered price to leave room for a negotiation. Cameras and lighting are examples of small-ticket items. Buildings and automobiles are examples of large-ticket items.

PHOTOGRAPHIC PURCHASES

I don't want to create any false expectations about being able to negotiate for photography equipment. Most photography equipment is sold with a slim margin by high-volume dealers. There isn't much room to negotiate the price of a $2000 camera if the dealer is only making $50 over cost on it and is selling twenty of them a day. But opportunities to negotiate do exist and can be made. How do you recognize or create the opportunity?

I previously mentioned "margin." Like you, the seller has a bottom line. There is no benefit in taking a loss on equipment or supplies for sale. But there is a benefit in making some money instead of none. So you have to ask yourself what incentive will motivate the seller to lower the price? The answer is enough cash to make cash flow a bit easier, or a way to move an older product off the shelf to make room for newer ones.

Suppose you are going to change camera systems because technological advances have made your current gear obsolete. You might be purchasing a couple of camera bodies and four or five lenses. Your regional camera dealer's prices are always higher than the mail-order houses from which you usually buy equipment. The problem you encounter in doing so is that the shipping charges can eat up your savings, and sometimes the

items get back-ordered. But the biggest headache is when a piece of equipment is faulty when it comes out of the original box. The mail-order houses have quick systems for taking your money, but they do not keep pace when it comes to returning it or replacing defective merchandise.

Additionally, you want to trade in your existing system to reduce the out-of-pocket payment for the new gear. The mail-order house will take trades, but you have to ship the gear to them to be inspected. Since you cannot be without either the new or old gear, you would have to ship it to the mail-order house after the new gear is purchased and received. That will hamper your bargaining power over its value, because you will not have the prospect of the new gear purchase to leverage against the sale of your old gear.

Finally, if you buy from the mail-order house, you will have to pay when you place the order and insure the shipment at extra cost, because the risk of losing an expensive shipment in transport is not one you care to take. Buying locally is beginning to look better and better, if you can just get a competitive price.

Strategic Buying

When you are buying, always remember that the seller is in the same shoes you are in when you are trying to make a deal. She doesn't want to lose a sale that she can make a profit on, as long as the hidden costs of that profit are not high. By hidden costs I mean hours invested to make the sale, grief from the buyer, and maybe even having the word get out that she cuts special deals. So you want to have your ducks lined up in an row—that is, know exactly what you want to buy, and what is the best price you can get somewhere else.

You also want to have a deal in mind. Don't count on the seller being creative. A busy retailer has little opportunity to get creative at the individual sale level. Just as you would prepare a proposal for a buyer, prepare a proposal for the seller. Having the total price you have been quoted elsewhere is important. When she sees a list of camera gear on paper, it is just that. When she sees a large dollar number on paper, she has to pay attention. Wouldn't you?

The total dollar figure will give her some idea of what her profit on the sale might be. Most likely, she knows the difference between her usual price and that being charged by her mail-order competition. With a bit of quick math, she can get a feel for what she will make from the sale.

You should know the total cost to you if you were to buy it from the mail-order house. By "total cost" I mean insured and delivered to your doorstep. You also should prepare a list of the gear you wish to trade in, if any. If you do, you are the seller and she is the buyer in that part of the transaction.

Finally, approach her about a special deal in private, not over the counter in her customer-filled store. She doesn't want to give the impression to others that she actually discounts merchandise when approached. You might send her a note or e-mail saying you would like to purchase the equipment on the enclosed list. Mention that you will be happy to come in and show her your used gear and discuss the price of the new equipment and promise her a call to set up a date and time to meet.

The next thing you have to do is think about what kind of options you can present to her. Chances are she is not going to spend a lot of time thinking about it. She has a bottom-line price, and it probably has little margin of profit. In other words, the sale may not be as important to her as you would like it to be. What can you do to increase its importance to her? The answer is to think strategically.

Strategic Thinking

Think about your counterpart's position in business. What big problem does she encounter and how can you motivate her through your understanding? She faces the same problem that you face. She is continually dealing with maintaining adequate cash flow without tapping reserves or borrowing money. How can your sale help her?

Proposal Timing

Most merchants pay their bills to suppliers within ten days of the end of the month. It is the period when they need the most cash on hand. If you can provide an influx of cash during that period, your sale is much more important to her than if you buy midmonth. You want to negotiate your deal when the buyer is most in need of cash. That is a time when the percentage of profit is not as important as the cash itself. Time your negotiations for that period, and be ready to pay fast. Many dealers will make great deals to get cash when they need it.

Avoid Snares and Add Incentive

You have your old gear to trade in. But that is not cash for her until she sells it. Since a trade-in would effectively decrease the amount of cash she would receive, it would decrease her motivation to make a better deal at bill-paying time. You can add incentive to the deal by asking her to sell your old equipment on consignment. That way, she has no cash outlay or reduction for

adding it to inventory, and you actually get more money. On a trade you will get about one half of the used selling price. When you sell on consignment, you can pay the dealer as little as 25 percent of the sale, and your gain is greater, albeit with a longer wait for the money than with a trade-in.

Some dealers won't deal in consignments or purchase used gear that is obsolete or approaching obsolete. Most customers want new technology, not old. Making your old equipment part of a purchase of new gear can be a snare in which you get caught. (The good negotiator sometimes sets traps into which he himself might step.) You can always sell the gear on an Internet auction or donate it to a charity for a tax deduction.

PITCHING THE DEAL

The pitch is simple. You want to buy locally, but you can't overspend to do so. You need the best price that you can get, and it has to be equal to that of the mail-order house. To get that deal, you are prepared to make the deal right now and pay right now.

This is a simple negotiating strategy. Equipment that the dealer has already paid for and has on the shelves is like having money sitting on your shelves that you cannot spend. When a dealer needs money to spend, selling off inventory is a great way to get it. You are just facilitating the process with strategic timing.

RESEARCH THE TIMING

Purchasing expensive items offers the best opportunity for negotiating, because these items usually have the kind of margin built in to their prices that gives the seller some leeway. An automobile

is a perfect example. If you have ever purchased a car, you know just what I mean: The dealer probably started out offering you a price *lower* than the sticker price. How much lower you got the price is dependent upon your negotiating expertise.

Researching buying cycles and timing your purchase for a slower buying cycle will help you negotiate a better deal. You can research buying cycles on the Internet. Let's continue with the example of the car purchase.

As a strategically thinking negotiator, you will take the time to learn about car-buying cycles. You will learn that most cars are sold in the spring or fall. The spring is the beginning of mild weather and precedes the summer driving season. Many people want a new car before vacation or for the springtime, when they make many day outings. They also don't like their cars to face the abuses of winter when brand new. Many others buy cars in the fall, because the new models are coming out, and dealers have special prices on current models to get rid of inventory. What does this tell you? It tells you that the car dealers have lots of business in the spring and fall. So it is not a strategically advantageous time to buy a car.

As you research car-buying trends, you find out that the worst sales period for car dealers is December and early January. The holiday season keeps many people engaged in other buying, the weather is not usually good, taxes start to be on people's minds, and, for some, seasonal depression is at its peak. That makes it a perfect time to buy a car. No one else is, and the dealership has bills to pay.

The best time to buy is between December 24 and January 5. Hardly any cars sell during that period. You can even have the added advantage of buying a previous year's leftover, which will drop in price on January 1 because it is last year's model. Yes, timing is important and, as the buyer, you can set the time you are ready to buy the car.

COMPETITIVE PRESSURE

You understand how competitive pressure is used against a seller, because it happens to you all the time. Now you get to turn the tables. Certainly you understand that you will need to comparison shop to get prices on the car you want from different dealers. That applies some competitive pressure. But how much does it apply?

If you want an X-ray 500 sedan, and you get three prices from three different dealers, you have reinforced in all their minds that you want an X-ray 500. I said *want*. Sellers want you to *want* what they are selling. It makes their job easier, and they don't feel as much pressure as they would if you were also considering a competitor's car. A competitive dealer selling X-ray 500s is not as threatening. They know the dealer's actual price and manufacturer's dealer incentives, since they apply to all X-ray dealers. They know successful competitive X-ray dealers will stop lowering price at a certain point, because they have been competing with them for years. They know their competition.

You should introduce some unusual competition into the mix. Let the X-ray dealers know that you are also considering and pricing Y-Streak 300, a competitive manufacturer's model meant to compete with the X-ray 500. By doing so, you have said that you *want* an X-ray 500 but you don't *need* it, because a Y-Streak 300 will do just fine. You have put a chink in the X-ray dealer's psychological mind-set.

The X-ray dealer can only guess at what incentives the manufacturers are offering Y-Streak dealers to move cars. These are not buyer incentives like rebates and low interest. These are special deals and terms for dealers. Now he has competition that he doesn't fully understand. That's real competition.

To get more advantage, don't mention the Y-Streak competition until after you have gotten the best price you can by forcing some competition among the X-ray dealers. Once you have the best price from a dealer, force that dealer to compete with the Y-Streak dealer. You will quickly find that there is still margin for the dealer to give up.

You can easily make a trade-off when buying a product that has upgrades, like the feature packages on a car. Price a lower feature package than you want. When you have the dealer competing against the other manufacturer's dealer, and you have pushed the price to its rock bottom, imply that you are going to take the competitor's deal. Then offer a trade-off. You will take his deal, if he will upgrade your car to have the package you want for dealer's invoice cost. You may not get the dealer's price, but you will get a big discount, because the feature packages have a greater percentage of profit than the base car and basic packages. Frills are wants, and wants cost more. Buy yours cheaper.

REMEMBER THE BASICS

The examples in this chapter demonstrate the benefit of doing research into the nature of the seller's business when you are going to purchase a high-priced item—that is, when you are actually likely to have an opportunity to negotiate. The methods and considerations portrayed here can be applied to other products and services. The critical similarity is, no matter what is to be purchased, that doing research, understanding the seller's hidden needs, and applying real competitive pressure will help you negotiate the best price you can get.

Chapter Ten

INTERVIEWS WITH
NEGOTIATORS

If you want to find pearls, you have to dive beneath the surface. In an effort to enrich this book, I interviewed three people. Two are photographers. One is a creative director who is responsible for negotiating with photographers.

The interviews were done by e-mail. I submitted the questions to each party, and the answers, presented below, have not been edited. Each interview is followed by a brief biography of the individual. I have made no comments about any statements made by any of the interviewees. You can draw your own conclusions from the interviews.

INTERVIEW WITH KERRY HILTON

1. There is a belief among many photographers that trying to negotiate with a client is futile,

because there is always some photographer who is quite capable of doing the assignment and who will accept any price the client offers to get the job. In your opinion, is this fear warranted and why?

I believe that every client (including myself) is willing to negotiate. Oftentimes, I have a photographer in mind for an assignment, and other times I have a budget that has been set. This is where balancing those two dynamics becomes an art in itself. I am always in need for well-crafted photography, but oftentimes educating a client on the cost is a challenge. I prefer to think of a photographer more like a partner than a vendor. If a photographer is willing to work with me, I am more willing to allow them to reap the benefits of a long-term relationship.

2. Obviously, price is an important factor in awarding a photography assignment. Other factors are also taken into consideration. In addition to price, six factors are listed below. Additionally, two blank spaces have been inserted for you to add factors also considered. Please rate each factor by considering its relative importance to price—that is, a factor might be equally important, not as important, or more important, than price.

Price: *Important*

Artistic skill (to innovate): *Equally as important as price.*

Photographic skill (to capture as directed): *Equally as important as price.*

Reliability (proven track record): *Equally as important as price.*

Personality (likeable): *More important than price.*

Experience (years in business): *Equally as important as price.*

Subject familiarity (experience with type of subject): *Not as important as price.*

3. Understanding that some situations are unusual, and that this answer might be different under unusual circumstances, what do you think are normally the three most important factors out of the seven listed above?

Personality
Photography Skill
Price

4. Copyright ownership of assignment images has been a contentious issue for many years. Photographers want to keep their copyrights for two primary reasons: 1) to be paid for additional and reuse of the images, and/or 2) to exploit possible value as stock images. Advertisers have reasons for demanding ownership of the copyright to assignment images. In your experience,

what are the primary reasons that advertisers want to own the copyright to the images commissioned on their behalf?

The primary reason that advertisers want to own the copyright to the images commissioned on their behalf is because they feel that the images belong to them. Plain and simple. A designer doesn't charge usage for a company's logo design. A copywriter doesn't charge usage on a headline. And more and more media commissions are being substituted for flat fees. Buying photography in their mind should be like buying anything else. Once you've bought it, you own it. The process of tracking usage for years to come is difficult, especially when today's marketing environment is a moving target. The attitude is: Buy it and move on.

5. The value of a photograph that is actually art directed includes the talent of the art director. The contribution of the photographer is made by either translating sketches into photographs or interpreting sketches in light of his or her own vision of the subject. Should art directors or their employing agencies have any claim to copyright in the resulting photographs, and why or why not?

Employing agencies may claim copyright of images that their art directors have created if they so choose. It really depends on how the agency is compensated for services. Agencies make money in a lot

of ways and oftentimes neglect to include copyright of images. An agency's relationship with a client may be short lived, and a client is going to want to retain all rights no matter who their agency is. I would suspect that an agency would not be hired in the first place if that was a negotiating point in the contract.

6. Photographers generally hold that their fees should be based on the level of use made of their photographs. They want to be paid according to usage, which includes the length of time, scope of distribution, and types of applications (brochures, ads, posters). In the advertising world, is this a realistic want?

In my opinion, yes and no. The world of usage has changed thanks to the World Wide Web. Almost everything I buy for a client has a likelihood of ending up on a Web site. And if you calculate the possibility of hundreds of thousands of repeated viewings globally, the price for a photo can become too expensive too quickly. Advertising budgets are being squeezed, and oftentimes smaller to mid-size clients will prefer to use royalty-free stock than to pay ten times the amount for 100 percent ownership of an image. This is true when you use lifestyle imagery that is not product specific. However, when the elements of product specific photography and photography expertise come together, usage is more likely negotiated. When photography needs are more of a commodity, usage doesn't seem necessary.

If yes, how can photographers present this concept to their clients?

Photographers must present their case from an artistic point of view. The reason that they require usage is because their style or expertise is unlike any other and is therefore worth it.

If no, why is it unrealistic?

It is unrealistic when an image is generic. Unfortunately, there are a lot of generic needs.

Do you have any other thoughts on this topic?

Eventually, usage will disappear, except for those few photographers who can demand usage based on their unique innovation and style.

7. Agencies have to create budgets for campaigns. As part of that process, they create budgets for the photography for the campaign. Understanding that most agencies have experience with fees and expenses for photography assignments, these budgets are usually adequate. In a situation when the photographers seeking the assignment consider it impossible to do the work within the defined budget (as envisioned by the agency and subsequently approved by the advertiser), is it more likely that the assignment will be trimmed back, or that the agency will seek additional funding

from the advertiser? Or, is it more likely that the agency will persevere until it finds a photographer who will do the work within the existing budget?

There is no one right answer to this. The agency will do whatever seems necessary, which will be any of these or a combination. I have done all of these. I have asked for more money. I have trimmed the assignment. I have persevered. If I had to choose, I think that I would most likely keep looking for a photographer that can work with me before I go and ask for more money.

8. When you request a price from a photographer, which are you more likely to seek: an estimate (allows some fluctuation in price), a quote (a binding price), a bid (a binding price in a formal competitive process)? Please feel free to elaborate.

I seek an estimate. The exact scope will change slightly, and a good client will know that or should have been educated on that. I assume that a photographer has some areas of pad in their estimate anyway.

9. What general advice can you give a photographer about negotiating with an advertising agency?

Be a partner. Work with them when they have small needs, and the bigger assignments will easily head

their way. Agencies will be very loyal to their partners in success.

10. How is digital photography changing the way photographers estimate an assignment?

Digital photography is changing the landscape of how a photo is taken and sent to an agency. Gone are Polaroid proofs. There is more flexibility for digital retouching, and the whole process has been stream-lined from the camera to a burned CD within hours. However, the value of an image is still based on day rates. Costs have been eliminated but replaced with other gadgets. Therefore, the real losers are the engravers who used to scan and color-correct images. Now, photographers offer that as either an added serv-ice or an added value.

KERRY HILTON BIOGRAPHY

A graduate of the Art Institute of Houston, Kerry Hilton has been involved in all aspects of advertising and graphic design. Before creating BRSG Austin, Inc. in 2001, Kerry served as creative director at Bozell Kamstra.

Part of his vast work experience includes such clients as Fujitsu, Hire.com, McDonald's, Whole Food Markets, The Black-eyed Pea, Johnson & Johnson, NEC of America, PruCare, and Playoff Trading Cards. He is also responsible for developing public service campaigns for Shots Across Texas (immunization), Texas Special Olympics, and a statewide recycling program ("Take Care of Texas. It's the only one we've got").

Kerry's work is best described as having a clean, simple style with emphasis on concept and strategy. Not only has his work won numerous advertising awards (Best of Show two consecutive years), but more importantly, it has been highly effective for his clients. Great advertising is advertising that works.

BRSG Austin is a full-service marketing communications firm with a staff of 30, headquartered in Austin, Texas. The company has grown to $20 million in capitalized billings.

Interview with Steve Hellerstein

1. There is a belief among many photographers that trying to negotiate with a client is futile, because there is always some photographer who is quite capable of doing the assignment and who will accept any price the client offers to get the job. In your opinion is this fear warranted, and why or why not?

Wow, in twenty plus years in the business I have never entertained such a notion.

Each and every job is a negotiation. Bottom line, I want to get paid as much as I possibly can and they want to pay as little as they can get away with. We always seem to end up somewhere in between! Seriously, one has to approach it from the perspective that they are the desired choice. After all, you were asked to bid the project.

I have always taken a rather contrarian approach to bidding projects. It has served me well.

Let me explain. Most every job is a triple bid, meaning they are going to get numbers from three different ideally equally qualified photographers. In this scenario, I always want to be the most expensive.

Here's why: Let's say one day you have a craving for some baked beans. You go to the grocery store and hunt down the bean aisle. There you stand, looking at all the options. Today it's going to be BBQ flavor. Yum. You pick up one can that sells for 39 cents, look at it, and notice on the shelf another can, same size, same flavor for $1.29. You pick it up and read that they both have the same ingredients. Confusion sets in. You end up taking the 39-cent can home, cook it up, and take that first delectable bite. Your very first thought: What would that $1.29 can of beans tasted like?

I can promise you that the next time you go shopping for beans, you'll buy the $1.29 can. Further, if you would have gotten the $1.29 can in the first place, you would never have wondered what the 39-cent one tasted like. You would feel confident you were eating the best there was and no looking back.

I want to be the $1.29 can.

You see, I'm in it for the long run. Sure, I may lose a few here and there, but we all know those are the tougher jobs and tougher clients. A smart client is who I want to work for; smart clients shop value, not price. I know what you're thinking: That may work for Steve, but my clients don't have the budget. In my experience, they'll find the money if they want to. It's your job to give them a reason to look for it. But, they won't if your book isn't stellar or if they know you'll always cave. Remember, your prices are setting the tone for

how you will be treated throughout the entire shoot. Demand respect and you'll get it. Ironically, the more they pay you, the more they'll respect you and, hence, your product. Conversely, lowballing (pricing under market so as to get the project) will always come back to haunt you. Further, it's bad for our entire industry.

Once you establish a price structure with a client, it is very difficult to move from that which was established. The notion that you'll do a project on the cheap to get them into your camp, then after seeing what a great shooter you are, they'll pay you what you are worth is hogwash. No matter how good, you'll always be a 39-cent can of beans. Not to mention that if anything goes slightly wrong on the shoot (which happens), you can bet someone will murmur under their breath (albeit unfair) "we should have gone with the other guy." You could part the Red Sea for them and I assure you, when they have a better budget, they'll go elsewhere. I'll be waiting.

I realize this is not for everyone. Further, you must realize this approach puts tremendous pressure on the photographer. You must deliver a project that exceeds their expectations creatively, is on time, on budget, and was an enjoyable, stress-free experience.

2. Obviously, price is an important factor in awarding a photography assignment. Other factors are also taken into consideration. In addition to price, six factors are listed below. Additionally, two blank spaces have been inserted for you to add factors also considered. From your experience with photography buyers, please rate each factor

by considering its relative importance to price—that is, a factor might be equally important, not as important, or more important than price.

a. Price: *Important*

b. Artistic skill (to innovate): *More important*

c. Photographic skill (to capture as directed): *More important*

d. Reliability (proven track record): *More important*

e. Personality (likeable): *Not as important. I am constantly amazed at how some of our peers treat their clients, and, for whatever reason, they keep going back.*

f. Experience (years in business): *Not at all.*

g. Subject familiarity (experience with type of subject): *It depends. Ironically, I've seen brilliant creative directors purposely hire outside of a genre in an effort to look at something differently. For example, hire a fashion photographer to shoot a car. The results usually accomplish the goal.*

h. Ability to instill confidence. *Very important, in this day and age where everyone position is tenuous at best.*

3. Understanding that some situations are unusual, and that this answer might be different under unusual circumstances, what do you think are normally the three most important factors out of the seven listed above?

Artistic skill, Artistic skill, Artistic skill (in that order)

4. Copyright ownership of assignment images has been a contentious issue for many years. Many corporations have reasons for demanding ownership of the copyright to assignment images. Photographers generally want to keep their copyrights for two primary reasons: 1) to be paid for additional and reuse of the images, and/or 2) to exploit possible value as stock images. In your experience:

a. Do you find copyright ownership to be a major issue in negotiating assignments for corporate work?

Not major, but it sure makes for an excellent bargaining chip. Additionally, one of the most overlooked benefits of copyright (which I have used many times) is expediting payment. This way, I'm not beholden to their terms. I am reasonable; however, if someone is extremely slow paying, you would be surprised how quickly you'll get a check by reminding them that they have no rights whatsoever to the image until it is paid in full.

b. What percentage of the time do you end up transferring copyright to clients?

Very rarely—less then a dozen times in my entire career. We're talking close to 6,000 assignments.

c. Do you have a fee schedule for different levels of rights granted?

Yes, you have to. I do it by percentages. For example, start with whatever the base usage is—then each additional use (duration or geographic) is an additional 25 percent, maxing out with a buyout being an additional 100 percent, and a transfer of copyright being an additional 200 percent. By doing it this way, one is less likely to mess up. Agencies will often have you estimate usage every which way conceivable, so that when they are asked the question from their client they will have the answer right at their fingertips. It better make sense; otherwise, you look like you're trying to pull something over on them—a surefire way to lose the opportunity to be seriously considered for the assignment.

d. Do your clients understand and accept the concept of more rights equals greater fees?

Absolutely. . . . Finish the equation: More rights means more exposure, more exposure means more sales, more sales means happy share-holders. . . .

5. The value of a photograph that is actually art directed includes the talent of the art director. When the contribution of the photographer is made by either translating sketches into photographs or interpreting sketches in light of his or her own vision of the subject, should

art directors or their employing agencies have any claim to copyright in the resulting photographs, and why or why not?

Whew. That's a tough one. I don't know.

6. Photographers are generally taught that their fees should be based on the level of use made of their photographs. They want to be paid according to usage, which includes the length of time, scope of distribution, and types of applications (brochures, ads, posters). How do you present this concept to their clients?

Fortunately, most all of my clients already understand this. If not, I'll explain that it's as if we are going into partnership on the success of the project. If it does well, they will want to continue to use it and perhaps expand where it is posted. Hence, more sales means more $$$. I should then be further compensated for my contribution to its success. (The agency is likewise compensated as a function of their commission on the placement.) Likewise, if it isn't working for them, they should not have to pay as much, as they are not benefiting financially from the image. It's kind of a win/win situation.

7. Do you have any other thoughts on this topic?

Usage can be one of the most difficult concepts to grasp until one sees it in practice. Then

all of a sudden it becomes very clear and easy to grasp.

8. Companies have to create budgets for projects. As part of that process, they create budgets for the photograph. Understanding that most companies have experience with fees and expenses for photography assignments, these budgets are usually adequate. In a situation when you consider it impossible to do the work within the defined budget (as envisioned by the company), is it more likely that the assignment will be trimmed back, or that the company will increase the budget? Or, is it more likely that the company will persevere until it finds a photographer who will do the work within the existing budget?

I make it my business to find a way to do the job without compromise and keep it in my camp. They will always forget about the budgetary constraints once the job is awarded.

9. When you are asked to provide a price to a client, which are you more likely to be asked for: an estimate (allows some fluctuation in price), a quote (a binding price), or a bid (a binding price in a formal competitive process)? Please feel free to elaborate.

Well, an estimate that is really a quote and called a bid (in the case of overages!).

10. What general advice can you give a photographer about negotiating with a client?

Get as much as you possibly can!

11. Write your own question and answer.

Q: What profession must you be a carpenter, a manager, a talk-show host, a financial whiz, a writer, a technician, creative on demand, diplomatic, charming, a financier, have impeccable taste, know all of the customs of every culture, a mover, a trendsetter, a travel agent, a casting coach, a location scout, . . .
A: You guessed it. Ours. Good luck. Remember: Beans, beans the magical fruit. . . .

STEVE HELLERSTEIN BIOGRAPHY

As a recent graduate of the Art Center College of Design, Steve Hellerstein came to New York in 1983. After a brief stint assisting, Hellerstein went on to become one of New York's top advertising shooters for over two decades. Steve has won every major industry award to include 9 One Show Pencils and both a Gold and Bronze Lion at Cannes. His clients include Sony, Intel, Evian, Pepsi, Coke, IBM, DeBeers, Smirnoff, Accenture, Lancôme, and United Airlines.

In addition to shooting constantly, Hellerstein serves on the creative advisory board to the Creative Circus in Atlanta. Past advisory board positions include the Portfolio Center (in Atlanta), New York Public Schools, and The Art Institutes. In 2000, he was elected president of the New York chapter of the Advertising

Photographers of America (APA). He went on to serve as the APA national representative for copyright reform.

Hellerstein lives in Brooklyn with his nine-year-old son Max, who wants to someday . . . open a spa?

INTERVIEW WITH JAMES CAVANAUGH

1. There is a belief among many photographers that trying to negotiate with a client is futile because there is always some photographer who is quite capable of doing the assignment and who will accept any price the client offers to get the job. In your opinion, is this fear warranted, and why or why not?

The fear is indeed warranted to some degree, depending on the sophistication of the buyer. In any business, there is always someone "cheaper." Some of these "cheap" photographers are adequate photographers but foolish business owners. They meet the needs of clients where price is the only issue.

Thankfully, for some clients price is not the ultimate decision point. Quality and, perhaps more important, reliability are important to many. However, you must be aware in today's economy price always has some level of influence in the decision process.

A key point is the client's perception of value. Is the higher price worth a better product/service? Another factor that must be assessed is who is the final decision-maker relative to the budget approval.

Oftentimes, buyers are under pressure to keep total project costs at some predefined level. If costs are above the limit set, then it is up to the buyer to sell the increase to their client or employer. In these cases, I try to have that person involved in the negotiation process.

2. Obviously, price is an important factor in awarding a photography assignment. Other factors are also taken into consideration. In addition to price, six factors are listed below. Additionally, two blank spaces have been inserted for you to add factors also considered. From your experience with photography buyers, please rate each factor by considering its relative importance to price—that is, a factor might be equally important, not as important, or more important than price. Feel free to add factors as you wish.

Price: *Important*

Artistic skill (to innovate): *Equally important*

Photographic skill (to capture as directed): *Equally important*

Reliability (proven track record): *More important*

Personality (likeable): *Not as important*

Experience (years in business): *Not as important*

Subject familiarity (experience with type of subject): *Equally important*

Reputation: *More important*

3. Understanding that some situations are unusual, and that this answer might be different under unusual circumstances, what do you think are normally the three most important factors out of the seven listed above?

Reliability, reputation, and photographic skill. These are the key elements that I sell myself on. When a client assigns a photographic assignment, there is pressure on them to have the project completed successfully. If the photographer does not complete the assignment properly, the buyer is on the "hot seat." Convincing the client they do not have to worry, the assignment will be completed in a professional and timely manner, has great value to many buyers. In the negotiation process, building credibility while alleviating concerns is critical. This is especially true in negotiations on creative services like photography.

4. Copyright ownership of assignment images has been a contentious issue for many years. Many corporations have reasons for demanding ownership of the copyright to assignment images. Photographers generally want to keep their copyrights for two primary reasons: 1) to be paid for additional and reuse of the images,

and/or 2) to exploit possible value as stock images. In your experience:

Do you find copyright ownership to be a major issue in negotiating assignments for corporate work?

No, as an architectural and aerial photographer, it is not much of an issue. However, unlimited use is often an issue that must be addressed.

What percentage of the time do you end up transferring copyright to clients?

I have not done this for over two decades. However, on occasion, I do grant unlimited, non-exclusive rights.

Do you have a fee schedule for different levels of rights granted?

Yes.

Do your clients understand and accept the concept of more rights equals greater fees?

The level of sophistication and understanding of these issues by the clients I work with is somewhat limited. Explanations are often required. The irony is that most of my clients only need a limited bundle of rights to deal with their own direct marketing efforts. They rarely have the budgets

(or need) to use the images in high-end applications such as print advertising or out-of-house display.

5. The value of a photograph that is actually art directed includes the talent of the art director. When the contribution of the photographer is made by either translating sketches into photographs or interpreting sketches in light of his or her own vision of the subject, should art directors or their employing agencies have any claim to copyright in the resulting photographs, and why or why not?

This is not an issue in my work. I do believe it can be a valid issue in the case of tight artist comps or "hands-on" art direction on the set. I think that a valid claim can be made for joint copyright in these cases. The difficulty is in drawing the line.

6. Photographers are generally taught that their fees should be based on the level of use made of their photographs. They want to be paid according to usage, which includes the length of time, scope of distribution, and types of applications (brochures, ads, posters).

How do you present this concept to their clients?

Most price conversations start with "How much does it cost?" or "What is your day rate?" I promptly

reply that the price depends on three factors: the production time, the expenses related to the project, and, most important, the use of the photographs. I will explain that I have a base fee for a specific bundle of marketing rights. I will go on to explain that for the majority of my clients, this meets their needs. I will also ask if they anticipate any additional use. In many cases, they are "not sure." I will often offer to bill them the base fee, agree to a set fee for the additional use, and then only bill them for the additional use if they actually need it. Most do not.

7. Do you have any other thoughts on this topic?

For many of the small companies I deal with, the issue is moot. As I noted above, most of my clients cannot afford to buy the type of space where additional licensing rights would be needed. Harping on this point is fighting a battle where there is no war. When rights do become an issue, I think the key is to reassure the client that they will not be prevented from using the images in the future. I achieve this by negotiating future usage rates that we can agree on in advance. The reality is that very few clients actually ever need the future use. However, the photographer needs to understand that the buyer is being motivated by the fear that they may not have access to the images in the future. Unfortunately, this fear often stems from bad experiences with previous photographers.

8. Companies have to create budgets for projects. As part of that process, they create budgets for the photograph. Because most companies have experience with fees and expenses for photography assignments, these budgets are usually adequate. In a situation when you consider it impossible to do the work within the defined budget (as envisioned by the company), is it more likely that the assignment will be trimmed back, or that the company will increase the budget. Or, is it more likely that the company will persevere until it finds a photographer who will do the work within the existing budget?

There are times when the actual cost and a client's budget are so far apart that there is no middle ground. After nearly thirty years in this business, I am still stunned when I hear some clients' proposed budgets. My favorites are the people who call for an aerial photograph and think it will cost $50.00! In these cases, I simply walk away.

In some of these cases, unsophisticated buyers will simply shop until they find someone who will agree to the low price, no matter how poor the final quality. However, in many cases, I try to find ways to make the assignment work. If the price is somewhat low, I ask, "Why was the budget set at that level?" Their answer will provide great insight into their mind-set about the project or photography in general. When I have a better understanding of their needs, I can implement a strategy to change

the scope of the project with the goal of gaining the assignment.

9. When you are asked to provide a price to a client, which are you more likely to be asked for: an estimate (allows some fluctuation in price), a quote (a binding price), or a bid (a binding price in a formal competitive process)? Please feel free to elaborate.

I always use the term "estimate." I often tell my clients that the estimate is a "flexible document" based upon our "initial discussions." I let them know if the scope of the assignment changes, the estimate can reflect those changes. I think this flexibility is a plus in the minds of my clients. This is because many clients are simply looking for some idea of what a proposed project may cost.

I find that I am in a bidding situation in well over half of all projects I am asked to prepare a proposal for. (I always ask if I am bidding, and against whom.) Even in these cases, I still use an estimate form, since the scope of the assignment often changes after the "bids" are presented.

10. What general advice can you give a photographer about negotiating with a corporate client?

Understand that you do have power in the negotiation. While you may be focused on the fact that you want the assignment, you must refocus your thoughts to the fact that they need someone to do the assignment. This

change in perspective provides you with leverage in the negotiation process. Also, if you act and speak like you already have the assignment, it will help create a psychological environment where the buyer will begin to see themselves working with you. This must be done in a prudent, non-arrogant manner, asking plenty of questions and offering suggestions about how you will produce the assignment.

JAMES CAVANAUGH BIOGRAPHY

James Cavanaugh graduated from the New England School of Photography in 1975. He returned to Buffalo, New York, the same year and established his first studio. For ten years, he provided a wide range of photographic services to both consumer and commercial clients in western New York.

In 1986, Jim redirected his business and focused his marketing and creative efforts on architectural, interior, and aerial photography. Today, he is recognized as a leading specialist in these areas.

His clients include architects, engineers, interior designers, contractors, real estate developers, architectural product manufacturers, and government agencies. His publication credits include *The ASMP Bulletin, World Architecture, Reader's Digest, Progressive Architecture, Rolling Stone, Business Week, American Banker, SSL, Seaway Review, Parents, Women's World, Ladies Home Journal, Techbits, Rangefinder,* and *Design Portfolio.* Jim was also featured in Eastman Kodak's "Vision in View" video program. Jim teaches Professional Business Practices in Photography at Villa Maria College in Buffalo and is also a frequent guest lecturer at the Rochester Institute of Technology.

Jim is a member of the American Society of Media Photographers (ASMP). He is a former national director and vice president of the association. He also served as chairman of ASMP's Specialty Group Relations Committee and is chairman of the Business Practices Committee of the Architectural Photographers Specialty Group. He is also the president of the Western New York Chapter of ASMP. He is an allied representative to the Buffalo/WNY Chapter of the American Institute of Architects. He is a strong advocate of copyright issues and ethical business practices in photography.

Chapter Eleven

Learning What this

Book Teaches

In the Babylonian Talmud it says: "Learning is more important that practice because learning leads to practice." Like most ancient wisdom, there is an undeniable truth in those words. Practice is a way to polish what we know. Learning is getting to know what we will later practice.

First Things First

Learning to negotiate starts with having a solid knowledge of the topic. The first five chapters of this book are: 1) The Nature of Negotiation, 2) Traits of a Good Negotiator, 3) Planning for a Negotiation, 4) Psychological Aspects of Negotiating, and 5) Negotiating Strategy and Tactics. These five chapters lay the groundwork for the rest of the book's content. They are the most

important chapters in the book, because they address the groundwork on which all negotiating efforts are built.

You could *take* photographs before you learned the basic science of photography. Once you learned the basic science, you were ready to learn the techniques. Once you learned the techniques, you were ready to *make* photographs. Chapters 1 through 5 are the basic science of negotiating. The rest of the book is about techniques.

At this point in the book, you are nearly done. You might be anxious to apply what you have learned. You should do that. You should also read the first five chapters again, and maybe even several times over. The mind-set of a negotiator is fortified by understanding the basics, just like the mind-set of a photographer is when it comes to doing photography. You didn't learn the basics of photography by a casual reading on the topic. You studied the topic. And you learned the topic. There is no reason to think that learning to negotiate is any different from learning to photograph.

Take Notes

Learning requires discipline. One discipline is note-taking. You can kill two birds with one stone by taking notes as you read. First, it will provide you with a means to refresh your memory periodically, and, second, it will help you practice the process of note-taking, which is an indispensable skill for the negotiator. If you keep your notes neat and concise, they can be used as a reference in real-life negotiations. Trying to quickly refresh you mind by skimming a book is much harder than reviewing a set of concise notes.

HOMEWORK SHEETS

You can also make lists of questions to which you want the answers for planning your negotiations. Who, what, when, where, how, and why are important interrogatories. When you reread chapter 4, you should make lists of questions based upon the examples given in the chapter. I purposely did not include a list of questions for you in this book, because I know that you will *learn* the questions, rather than just use the ones I could give you, if you make the lists yourself. And you want to learn, not just use.

REFLECT ON YOURSELF

As you reread about the nature of a negotiator, reflect on your own nature. Do you have the traits of a successful negotiator? Do you have to adapt? If you have to adapt, just what traits do you have to work on and how can you do this? The answer is to develop a sense of self-awareness and to discipline yourself where you are lacking. If you know yourself to be a poor listener, ask yourself if you are listening when someone is talking to you. If you are not, concentrate on what they are saying. The success of a negotiator is connected to the ability to understand another's point of view. You cannot do that unless you listen to them. If a negotiator acts like the world revolves around him, it will be a very small world doing the circling.

Consider each trait of a good negotiator, assess your level of achievement in that area, and then work on those areas in which you are lacking. It is a matter of mental discipline. You have to

exercise mental discipline to be a good negotiator, so you might as well start doing so in a self-assessment process.

Continuous Learning

As a photographer, you must continually learn about your art and craft. There is always some new insight to be gained. You read about photography, you look at pictures, you attend seminars and workshops, and you experiment.

Being a good negotiator requires continual learning. There are dozens, if not hundreds, of books on the topic. There are seminars on the topic. You should read other books and participate in seminars. Most books and seminars are general in nature. Unlike this book, they are not written for a specific audience. But that does not matter. After reading this book, which has been geared to media photographers, other books will make more sense to you. You will easily adapt the information to your own specialized need. The same thing is true of seminars.

Learn through Review

As you engage in negotiating, you will undoubtedly find yourself in situations when you are stumped for an answer or a tactic to employ. While most of us like to forget such uncomfortable moments (for our own peace of mind), I assure you that your peace of mind will be much greater when you purposefully remember what went wrong. By reviewing such moments, you can reconsider what you might have said to a statement or question that you were not prepared for. You will eventually hear the same statement or question again in the future. If you have

reviewed and reconsidered the matter, you will be ready to deal with it next time. Each time you have a bad moment while negotiating, review the moment in your mind. Consult this book or your notes and ask what did you do wrong, what tactic could you have employed, what answer might you have given. In doing so, you will develop an arsenal for future negotiations.

LEARN THROUGH PRACTICE

Practice in itself is not learning. It is developing skill based upon how you use what you have learned. But practice offers you the opportunity to learn because of it. By practicing negotiating, you will find your weaknesses before you engage in the real thing. Practice with a colleague who also wants to perfect negotiating skills. Switch roles as buyer and seller. Develop scenarios that mimic real-life experiences in business.

Review your practice sessions just as you would review a real negotiating session. Look for your weak points during the practice, and consider what you might have done differently. Then try running through the same scenario again. It is just like training as an athlete or performer. You practice each play, step, and action. When you make a mistake, you review what it was. Then you do it again until you get it right. Each practice helps you learn more about what you are doing.

TALK TO YOURSELF

Don't worry about being seen as crazy. Talk to yourself as if you were in a negotiation. Years ago, I photographed a champion chess player. I asked how he learned to play chess. He said that his

father had taught him the basics. He learned from experience of actual games. He learned through practice by playing with others. But he also learned by playing against himself. He would play both sides, in effect trying to stump himself. He would set up a terrible chess scenario on the board and than play to fight through that scenario.

You can do a similar thing. Ask yourself that question or present to yourself that demand that you fear the most. Then build your answer to it. Speak your reply to yourself. You will know when you have it right. Of course, close the door to the room, or people will think you are nuts.

Acknowledge the Essentials

You have to develop a feeling for the quintessence of negotiating, not just a knowledge of the methods. The heart of the process is based upon the sound principles stated in this book. They are not my personal concoctions. They are time-proven and well-recognized principles of negotiating. Some of the most important of these principles are re-emphasized below in the words of men who considered the topic of negotiating long before I did.

- **The Fair Deal:**

 "The old idea of a good bargain was a transaction in which one man got the better of another. The new idea of a good contract is a transaction which is good for both parties."

 Louis Brandies, 1856–1942
 U. S. Supreme Court Justice
 Business—A Profession

- **Two Willing Parties:**

 "A man whose *word* will not inform you at all what he means or will do is not a man you can bargain with. You must get out of that man's way, or put him out of yours."

 Thomas Carlyle, 1795–1881
 Scottish Essayist
 On Heroes and Hero Worship

- **Options Are Essential:**

 "The greatest strength of the negotiator lies in thinking up new proposals as soon as strong objections are made."

 CEO, AEG (General Electric Gremany)
 Reflexionen, 1908

- **Exercise Patience:**

 "Don't negotiate with yourself. Have the patience to wait for the other fellow to make a counter-offer after you have made one."

 Richard Smith
 Partner, Smith, McWorter & Pachter
 Speech, Washington D.C. 2/12/1988

Make the Effort

Your success as a negotiator will depend on how well you have learned to negotiate. That will depend on how much study and practice you have done. It will also depend on how well you perfect your knowledge and skills by the review and revision of attempts gone awry. Success is always about the effort of applying

knowledge. Learning not only provides the knowledge, but it also motivates additional effort. Make the effort to learn how to negotiate. As you learn, you will feel like making additional effort. Remember: Success feeds on success. Make the effort now, and you will be successful in your negotiations. That can lead to a very successful business.

Index

Books from Allworth Press

Allworth Press is an imprint of Allworth Communications, Inc. Selected titles are listed below.

The Real Business of Photography
by Richard Weisgrau (paperback, 6 × 9, 256 pages, $19.95)

Photography Your Way: A Career Guide to Satisfaction and Success, Second Edition
by Chuck DeLaney (paperback, 6 × 9, 336 pages, $22.95)

ASMP Professional Business Practices in Photography, Sixth Edition
by the American Society of Media Photographers (paperback, 6 3/4 × 9 7/8, 432 pages, $29.95)

Photography: Focus on Profit
by Tom Zimberoff (paperback, with CD-ROM, 8 × 10, 432 pages, $35.00)

Business and Legal Forms for Photographers, Third Edition
by Tad Crawford (paperback, with CD-ROM, 8 1/2 × 11, 192 pages, $29.95)

The Photographer's Guide to Marketing and Self-Promotion, Third Edition
by Maria Piscopo (paperback, 6 3/4 × 9 7/8, 208 pages. $19.95)

How to Shoot Stock Photos That Sell, Third Edition
by Michal Heron (paperback, 8 × 10, 224 pages, $19.95)

Pricing Photography: The Complete Guide to Assessment and Stock Prices, Third Edition
by Michal Heron and David MacTavish (paperback, 11 × 8 1/2, 160 pages, $24.95)

The Business of Studio Photography, Revised Edition
by Edward R. Lilley (paperback, 6 3/4 × 9 7/8, 336 pages, $21.95)

Starting Your Career as a Freelance Photographer
by Tad Crawford (paperback, 6 × 9, 256 pages, $24.95)

Please write to request our free catalog. To order by credit card, call 1-800-491-2808 or send a check or money order to Allworth Press, 10 East 23rd Street, Suite 510, New York, NY 10010. Include $5 for shipping and handling for the first book ordered and $1 for each additional book. Ten dollars plus $1 for each additional book if ordering from Canada. New York State residents must add sales tax.

To see our complete catalog on the World Wide Web, or to order online, you can find us at ***www.allworth.com.***